MAKING SIMPLE CONSTRUCTIONS

MAKING SIMPLE CONSTRUCTIONS

By Hansi Bohm

Watson-Guptill Publications, New York

First Printing, 1972

First published in the United States of America *1972* by Watson-Guptill Publications,
a division of Billboard Publications, Inc.,
165 West 46 Street, New York, N.Y.

Copyright © 1971 by Hansi Bohm
First published in Great Britain by Studio Vista Limited in 1971
General editors Brenda Herbert and Janey O'Riordan

Manufactured in the U.S.A.

Library of Congress Cataloging in Publication Data
Bohm, Hansi.
 Making simple constructions.
 Bibliography: p.
 1. Handicraft. 2. Assemblage (Art) I. Title.
II. Title: Constructions.
TT910.B64 745.5 70-190516
ISBN 0-8230-2995-6

Contents

Introduction

What is a construction? The word is used to describe any form of creative work that cannot be defined either as painting or sculpture. These time-honoured definitions, laid down by the temples of High Art, the Academies, began to disappear just before World War I and are now blurred and almost meaningless. Paintings are sometimes built up with all sorts of materials until they are thick enough to be called reliefs; sculpture need no longer be of white marble, cast bronze, or carved out of a block of wood or stone. Modern art has done away with these concepts by combining three-dimensional form with colour, by discarding the idea of a solid block from which an image can be liberated, and by using modern industrial materials which can branch out into space, enclosing empty areas as part of the work.

Despite unorthodox ideas and materials, there is still a great deal of solid craftsmanship needed for serious works of art. But this book is not concerned with such pursuits, bur rather with the creation of more lighthearted objects — objects of decoration or fun which can be made with a minimum of craftsmanship or cost but which will satisfy our need to be creative and give scope to our inventive imagination, to our sense of form and colour, to our taste and aesthetic sensibilities. This need to play, to make things, may lead us to create three-dimensional objects simply for the fun of doing them and the pleasure others will derive from looking at them. There may of course be special occasions to trigger off our activities, such as decorating a house, a hall, a garden or a village for special festivities — but even without any particular purpose in mind we can enjoy making such pieces, by ourselves or with the family on a rainy Sunday.

For lack of a better word, then, such three-dimensional pieces are called constructions. They can be decorative panels to hang on a wall or to form a screen — dividing a room or fitted into a fireplace; panels of low relief or high relief, made from a single material or from many. They can be free-standing pieces approximating sculpture, large or small. They can be hung from the ceiling or on the wall, as fixed objects or as mobiles in which the components move separately. They can be austerely all-white or all-black, or gaily coloured, or left unpainted to show the characteristics of the original material. Once you get away from tradition, there are no limits to what you can do and no definite rules to be followed. I propose, therefore, to show in this book a selection of

work made from a wide variety of materials and to describe how each piece was put together; and I hope that these examples will stimulate your imagination and encourage you to explore the fascination of inventing your own constructions.

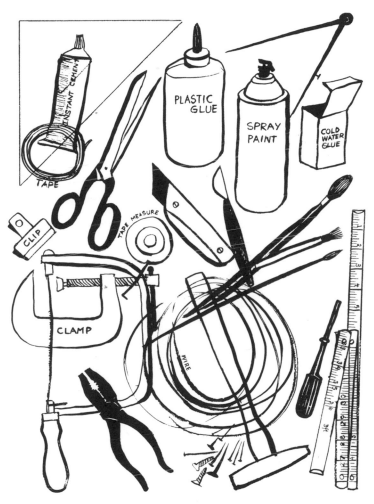

Fig. 1 Tools

Tools and materials

Tools

The tools needed for making simple constructions are essentially those used for ordinary household repairs, though you may occasionally need to branch out into more specialized fields as you become more adventurous. Here is a basic list of things you will find useful:

scissors
hammer
screwdrivers
ruler
tape-measure, yardstick
drill
metal saw, hack(saw) wood saw
pliers
a plumber's candle (a short fat candle obtainable from most hardware stores)

a good knife, such as a Stanley craft knife or other holder with replaceable blades (mat knife)
brushes for paint and glue
nails, drawing pins (thumbtacks)
wire, various thicknesses and types
spray paints
Scotch tape or masking tape
rags
sandpaper in various grades
spring clips for holding parts together while gluing

Clamps, obtainable from tiny to very large, are most useful for work with wood or metal, either to hold an object down to the working surface or to hold parts to each other; it is best to buy them as need arises, to avoid accumulating an unnecessary stock.

A solid, clean working surface is important. The kitchen table will do in most cases, but having to clear up between working sessions is a disruptive nuisance. Also, a certain amount of mess lying about can inspire you with new ideas; and it is helpful to be able to keep your tools close to where you are working. Remember, when using spray paint or varnish, to protect the surroundings.

For those who are mechanically minded or lucky enough to possess a proper workbench, I would recommend a vice fixed to the working surface and a $3/_8$ in. electric drill.

Adhesives

There are so many proprietary adhesives on the market that it is impossible to specify any particular kind; you will find it useful to have one each of the following types:
cold water paste (or white glue)
plastic or resin glue
an impact type glue or cement
Ask in your local hardware shop for the type of glue most suitable for the material(s) you are working with, and follow the maker's instructions for use.

Materials

One of the exciting things about making constructions is that almost anything can be used as raw material if it interests you and inspires you with ideas. Below is a list of the kind of objects and materials which are worth looking out for and collecting.

NATURAL
shells
stones and pebbles
bark, moss and lichen

seeds and seedpods
feathers
driftwood and roots

MAN-MADE
wood — blocks, boards, rods (dowel), panels, turned objects, veneer, plywood, matches, toothpicks, etc.
glass — transparent or tinted, panes or rods, bottles or lenses, mirrors, beads, marbles
Perspex (Plexiglas) — sheets, boxes, rods, beads
cloth — hessian (burlap), vynil, felt
acrylic modelling paste
cotton wool (absorbent cotton)
steel wool
glass-fibre wool (Fibreglas)
pins and nails
wire, wire-netting
tinfoil, copper and brass foil
thin aluminium sheets
paper, cardboard, corrugated board

plaster of Paris
cellulose filler
expanded polystyrene
 (Styrofoam)
letters and numbers (as for
 doors)
washers
coins
buttons
wheels, cogwheels
trademarks and slogans

DISCARDS

the contents of the waste basket and the junk yard

bottle tops, corks
plastic mugs and pots
lollipop sticks
egg boxes (cartons)
cardboard tubes
bus tickets and stickers
chains and metal springs
fishing tackle

knitting needles
old dolls
beads, broken costume jewelry
wood and metal shavings
reflectors, light bulbs
hairpins and rollers
coat hangers
clock and watch parts, often to be found in street markets and junk shops

Wood

In making your first constructions, it might be a good idea to begin with a material as familiar and as homely as wood, so warm to the touch and so much part of our existence from time immemorial. Wood is resistant but not too hard, it can be tackled in the most primitive or the most elaborate way, from gluing to nailing to screwing to dowelling to . . . marquetry inlay. We are in fact surrounded by works of reference for all this — in our furniture, for example.

If you want to make something with wood but cannot quite decide what, try playing about with any pieces of wood that are immediately available: for instance, a child's building bricks, a left-over length of dowelling rod sawn into pieces, or any offcuts from your own or a carpenter's workshop. Begin by assembling similar pieces of varying sizes, changing them around until you feel you have achieved some sort of rhythm and pattern, a mixture of repetition and variety; some irregularity will give it heightened interest through the tension produced by an 'odd man out'. Experiment in a playful manner, arranging the pieces this way and that; but when you have found what you want, glue it together at once, or draw a diagram of it if you want to experiment further — nothing is easier than to forget exactly how it went, and you might never retrieve a pleasing arrangement once you had lost it.

The relief shown in fig. 3 demonstrates the use of varying similar forms. It is built up entirely of squares, small and large, shallow and deep, but none as high as a cube. The support, which forms part of the relief, is a thick plywood board; two thinner plywood boards are glued to this, and the squares of varying thickness move around on top in a snail-like fashion. You will notice that the last square is the only one to reach the edge of the second flat base-square — this gives the whole design its movement. In the centre is a 'negative' square, left empty.

The individual shapes can either be sawn from timber of different thickness or cut from a plywood board and glued one on top of another until the desired thickness is reached. Any type of glue can be used; the traditional carpenter's glue, heated in a double boiler, is as good as anything but it takes longer to dry than the plastic glues, which dry fast. All surfaces and edges of the wood should be carefully sandpapered before assembly and when the glue is dry the finished piece can be sprayed with matt white paint. In this example some of the squares are painted in subtly differing greys.

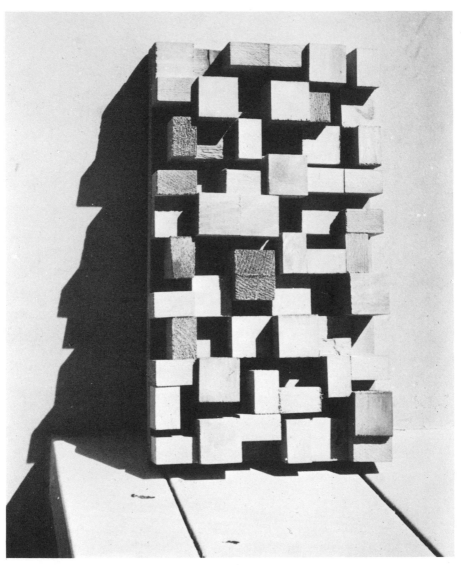

Fig. 2 Assemblage of wood blocks (Courtesy New York School of Interior Design)

To hold your wood while sawing off the pieces, you need a vice or a clamp; when using a clamp, put a small piece of wood between clamp and table to prevent denting. Mark out your lines beforehand and make sure the angles are correct: I shall never forget the cartoon of the man who wanted to even out the legs of his wobbly chair; he ended up by having only little stumps left under the seat.

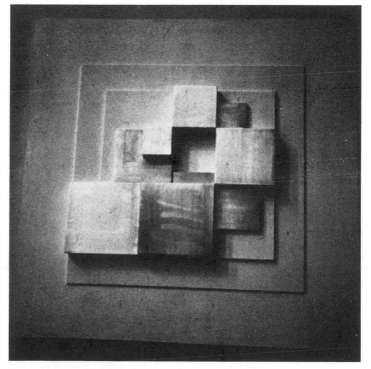

Fig. 3 *Relief* by Ann Casimir

The round discs in figs 4 and 5 were discards from a carpentry shop. The artist played around with them for some time, trying to realize a vaguely conceived idea, to bring the parts into the right relationship with each other. This piece presented more problems than the previous one because it is fully in the round and because it combines two contrasting basic forms: the flat discs, all the same, and the oblong board which forms a kind of connecting bridge between them. Once the position of the discs was decided, the places were marked and slots were sawn into the board and after sandpapering everything the discs were glued in place. When dry it was painted in high gloss enamel — the bridge white, the discs lemon yellow and orange.

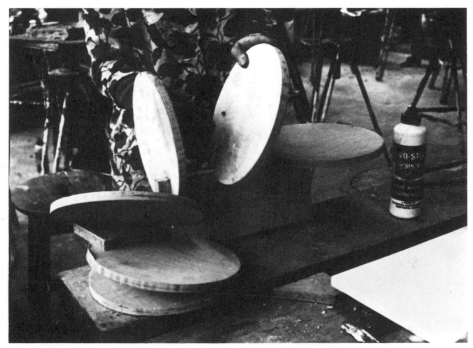

Fig. 4 *Windtunnel* (first stage) by Ann Casimir

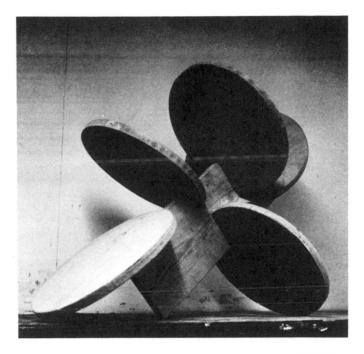

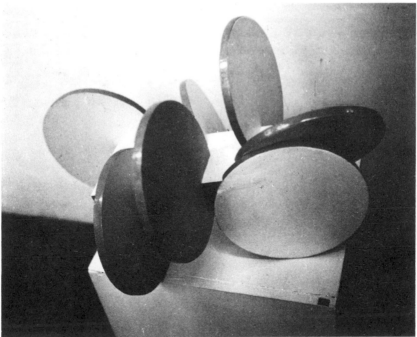

Fig. 5 *Windtunnel* (second and third stages) by Ann Casimir

Figs 7 and 8 show what can be done with one single unit of design. The basic unit is a cylinder (or rod), one end of which is cut off at a right angle, the other at an oblique angle. To vary this basic shape, the angles of the cut-off surfaces can be slightly altered and the slanting end can be further rounded off by sanding — but the principle of assembly remains the same: the slanting surface of each unit is glued to the supporting panel, with the blunt end standing out. The arrangement again gives scope for many variations. In fig. 7 you see units of varying lengths and diameter arranged apparently haphazardly in a little heap in the centre of the panel — each sticking out in a different direction; in fig. 8a units of two sizes are arranged following a right-angled grid; and in fig. 8b you can see the effects achieved by the contrast between empty areas and crowded ones. When finished, each panel is sprayed with brilliant matt white. The shadows produced by light falling on these pieces heightens the feeling of movement. White always accentuates the purity of any sculptural design, for light and shadow are part and parcel of any three-dimensional com-position. Colour complicates the issue — you *can* heighten the effect, but you may also counteract it unless you are very sure what colours will do.

It is interesting to compare the rod-panels in fig. 8 with the square relief in fig. 3. While the rod-panels seem to be sections of an infinite surface like the sea, the square relief is very much a closed composition, finite and individual.

'Vertical Construction' (fig. 9) is a two-element piece made from rods and oblong pieces of elmwood. It stands 3ft 11 ins high in its natural colour. You will see that the oblongs are of varying thicknesses, slightly curved and tilted one against the other.

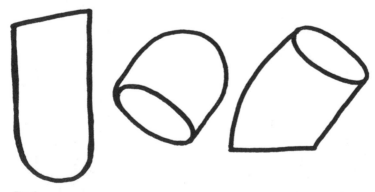

Fig. 6

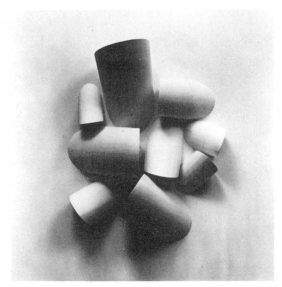

Fig. 7 *Relief* by Sergio Camargo

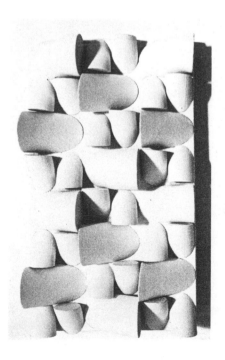

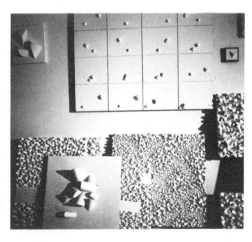

Fig. 8 Reliefs by Sergio Camargo

This is done with great sub-
tlety and sensibility, the up-
permost one almost floating
on those piercing rods, the
bottom one the most solid.
These rectangular pieces show
up well the difference between
a finely hand-made article and
a mass-produced one like the
discs in fig. 5 — it is craftsman-
ship against the machine. This
contrast is well exploited
within the construction itself:
the hand-made flat pieces are
set off against the machine-
made rods. It is a three-legged
piece (three legs are always
much easier than four); but
look how one rod stops and
another one takes over on the
other side in a syncopated sort
of way — very witty, and
charmingly animated.
Wood in miniscule is used
in fig. 10, a relief com-
posed entirely from one single
element of design: a little
stick. The background is a
softboard panel, the kind used
for bulletin boards; it is very
easy to fasten things to it:
you can glue, nail, staple, tape
etc. without difficulty as long
as your objects are not too
heavy. All the reliefs by this art-
ist (a commercial designer) have
a layer of acrylic modelling paste
all over the base, and are finally
sprayed with dull white paint
— the sort used for ceilings.

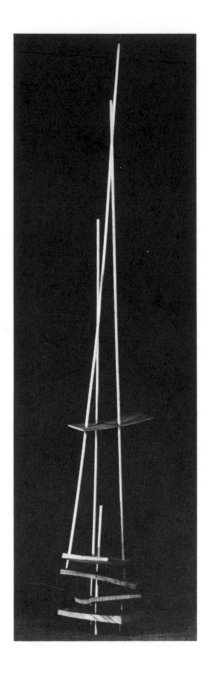

Fig. 9 *Vertical Construction* by
Robert Adams. Elm, 3ft 11 ins

This relief is one foot square and framed in a small boxframe, standing away from the wall. When you examine it you will notice that the distribution of sticks, apparently casual and accidental, is in fact carefully controlled. It is built up a bit like a nest, with the greatest concentration of sticks at the bottom left-hand; the density and height are also greatest at this point, tapering off gradually towards the right and the top and flattening out suddenly to the top left-hand corner. The general shape is a thick crescent with a few stragglers falling off to the right; these and the ones at top left are half embedded in the modelling paste, as if swimming on a pool of water; the dense core is built up high with glue.

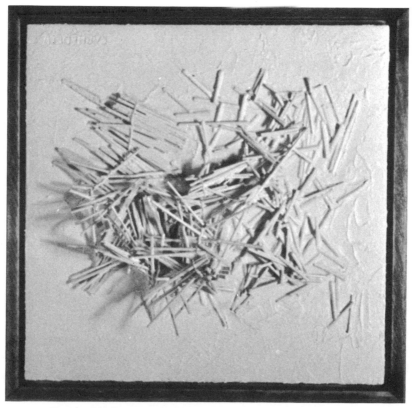

Fig. 10 *Relief* by Håkan Carheden

Discards

In the next chapter I shall be discussing the use of all kinds of found objects for making constructions; but the discarded remnants of everyday life are one particular kind of found object, and probably the most easily available material to collect when you are starting to make constructions. The waste paper basket, the dustbin and the scrap yard can yield an astonishing supply of treasures to someone with an imaginative eye.

I keep in my kitchen a bowl into which I put all sorts of little objects which appeal to me and which might one day serve me as material: chicken bones, fishbones, the snap-off clips from beer-cans, carrier-bag handles, egg cartons, plastic and wire fasteners, tin-can lids and the like.

The corks in fig. 11 came from this bowl. I played about with them for a while before it occurred to me to arrange them in a sort of swirling movement, a bit like a comma, with the biggest ones at the top and the sturdiest ones on the outside of the curve. I then took a sharp blade and trimmed them in diminishing order, downwards and to the left. There are thinner and fatter ones, some smooth ones and some with holes or with lettering on them; some are cut down to a mere disc. They were arranged so as to form a rhythmical pattern with enough variation between high and low, thick and thin, and the spaces between them, in order to avoid monotony — a slight risk when using only a single element of design. When the arrangement seemed right I glued the corks to the thick cardboard support; it is square — a very good shape against which to play a rhythmical design. When dry, the arrangement was sprayed with brass spray-paint and mounted on strips of wood 1 $\frac{1}{2}$ ins thick (to make it stand away from the wall where it was to hang); this frame is painted black.

The next illustration shows two variations on the same theme: an American city-dweller's statement about a bunch of flowers. I find this comment very sad, but it has been made in a witty and amusing form and it is valid for a nature-alienated urban society. The top part of fig. 12 shows a dowel rod stuck into a roller (as used in post offices for wetting stamps); on top of the rod is a softly modelled mass of plasticine (the foliage) to which are stuck some ping-pong balls (the flowers). The plasticine and the dowel rod have been painted white. The merit of this construction lies in the polarity between the soft, almost formless plasticine and the pristine clarity of the spheres. To avoid a slight monotony —

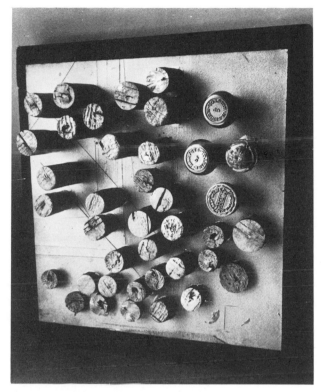

Fig. 11 Relief made with corks, by the author

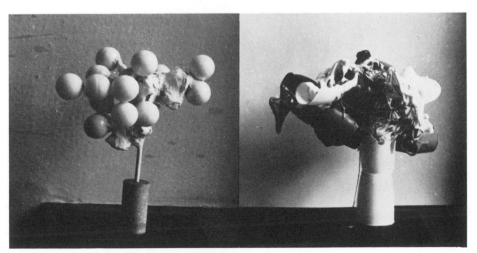

Fig. 12 *Bouquet* by Bill Amidon

some of the balls might have been embedded more deeply into the plasticine, some might have been cut in half to allow for a greater play of light and shadow.

The bottom part of fig. 12 is made from plastic mugs. Two mugs are glued together base to base and slightly off-centre, and out of the top comes a mass of melted mugs, green and white. The plastic has been melted over a plumber's candle (they are thicker and burn more slowly than ordinary candles) and allowed to flow over and into the supporting mugs. The contrast between the clean cylindrical form of the 'vase' and the soft melting, flowing and dissolving forms above give this construction its interest. A whimsical touch is added by the fine molten thread running down the side of the piece — humorous, yet perfectly consistent with the form of the whole.

Both pieces are fixed to black base-boards.

Another whimsical piece made of plastic is the relief mounted on a black board (fig. 13). A couple of coloured plastic mugs are melted onto the regular pattern of a plastic beer-can holder and from them drip three plastic spoons. Note how the spoons provide an unexpected break in the regularity of the pattern. The colours are black and primary.

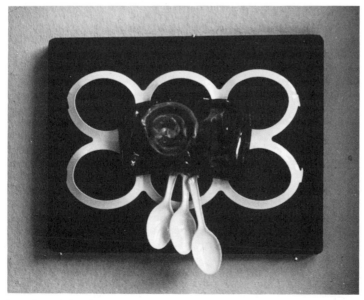

Fig. 13 Relief by Sharon Saxe

The Crucified Christ and the Roman Soldier (fig. 14) are made entirely from discards: old boards, pieces of timber, nails and rusty pieces of iron. The head of the Christ is made from two rusted-away iron discs, the crown from a handle or bracket; the arms and legs are twisted iron rods (the kind of thing that can often be found in old farm buildings). The soldier's helmet is made from a bit of tin bent over a wooden 'face' which is joined to a round piece forming the neck; the shield is the rusty lid of a tin can, the legs a rusty beer can, the lance a piece of iron rod with the tip, a bent bit of tin, loosely attached. This figure is screwed to a wooden base of irregular shape, while the Christ is hung from the wall. All the pieces of iron which make up the Christ are fixed to the timber behind them with nails knocked into the wood and then bent over the iron.

Although the way these two constructions are put together and the materials they consist of are very primitive, yet there is a sophistication about them which is difficult to explain – it is somehow like the definition of a cultured man: one who has forgotten all he ever learned.

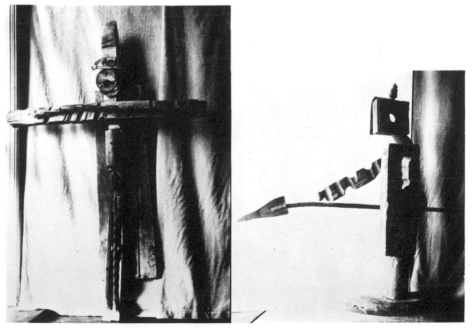

Fig. 14 (left) *Christ* and (right) *Roman Soldier* by Dr Ernest Shaw

The construction shown in fig. 15 is made from tobacco and candy tins, a steel rod and a few pebbles. These elements are glued together. The merit of the design lies in the contrast between the strong basic shapes of the tins, the smooth rounded pebbles and the graphic decoration supplied by the lettering on the tins. Although small in size, it is given scale by the balance of forms, and the distances and angles between them.

My next three illustrations should be regarded as sketches in three dimensions rather than as permanent, final works. As they are, they will serve as shortlived decorations for some special occasion, but they will not survive for long.

The one in fig. 16 is made from the cut-off rims of paper plates — black, white and yellow — intertwined and stapled together. This

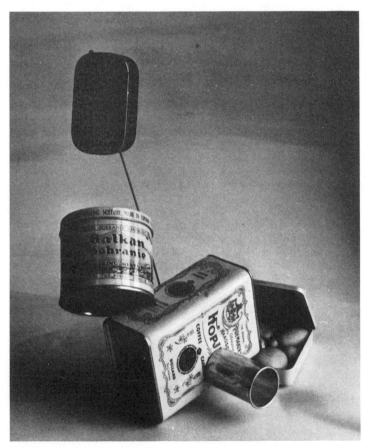

Fig. 15 Construction made with tins, by Emily Shaw

piece has no base and is shown here sitting on a shelf, but it could equally well be suspended from the ceiling or hung from the wall. It has no solid mass but is all linear movement, graceful and very feminine; its moving curves have a rococo feeling, full of rhythm.

For turning it into a more stable, permanent piece I would suggest the method used in the paper-bag construction (page 89, fig. 80), painting or spraying it with a thick layer of polyester resin in several applications. This will make it quite firm while keeping it light in weight. Another way would be to interpret it in a different material altogether, for instance in metal foil (copper, brass or aluminium). The stapling would have to be replaced by gluing of brazing. For brazing you need a blowtorch (there are butane gas torches on the market for home use which are quite easy to handle). Brazing needs quite a bit of practice and I shall suggest a handbook on it in the reading list at the end of the book. In using metal foil you would of course lose the stripey pattern of the rims and the colour, and you would have to consider other means of decoration; you might perhaps decide to leave the metal plain, making it matt on one side (with emery paper) and polishing it on the other. Or you could paint it in vivid enamel colours.

Thin metal foil can be cut with scissors, for the thicker ones you will need a sharp knife or even a saw. In making a piece like this in metal it is worth considering whether to cut straight bands of foil or whether to cut circles (drawn round two different sized plates placed upside-down); they will twist in a different way.

Any adaptation of a model (sculptors call a 3D sketch a maquette) to another size or another material needs rethinking and very often some alteration of the design, because every material has its own qualities and characteristics; materials used successfully in one piece may not work so well in another — but most materials somehow suggest how they can best be handled and one can exploit the possibilities offered by them.

Fig. 17 shows an equally impermanent creation. It is a wild insect, really wicked-looking, made from wire coat-hangers. The hangers are bent and twisted and hooked together with bits of thin wire. The solid area in the middle is covered with thin wrapping paper printed in red and yellow; the wires are covered by pink tissue paper, cut into strips and rolled round. You can see one wing partly covered by wound-round strips of pink: the pattern made by the strips is not accidental — the loops echo

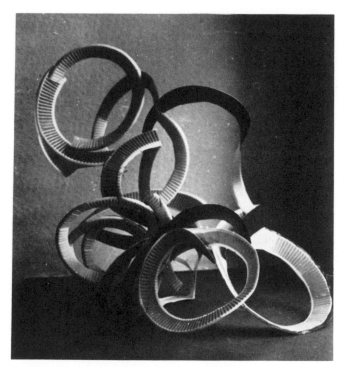

Fig. 16 Construction by Sharon Saxe

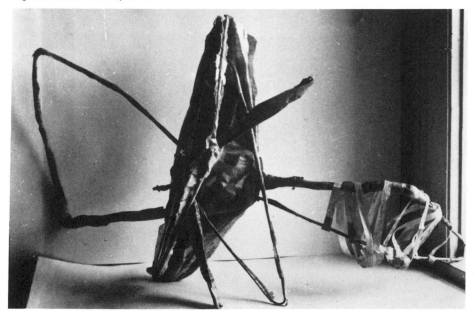

Fig. 17 *Insect* by Deirdre Philipps

the loops of the hangers. The hot pink and orange colours used somehow make the object very like a beetle.

Like the previous one, this piece based on a column (right) also has a festive, carnival air about it. The warm colours — red, pink and yellow — add to the feeling of wildness and gaiety. It is made from a cardboard tube painted bright red, with cane rings suspended from pieces of cane stuck into holes in the tube. Cut-outs of tissue and crêpe paper are glued into the rings or wound over them; bits of thick red wool make the stamen-like fringe on the left. The decoration of the rings is reminiscent of primitive designs on native fabrics and embroideries. The technique is primitive too, improvised and fragile. In adapting this model to something more permanent, it could be made less central to the column, looking less like a maypole. The cane could perhaps be replaced by wire and the paper by plastic, or wood and metal could be used. Cane (reed) can be obtained from hobby and craft shops. It must be soaked in water for at least an hour before bending it to the required shape.

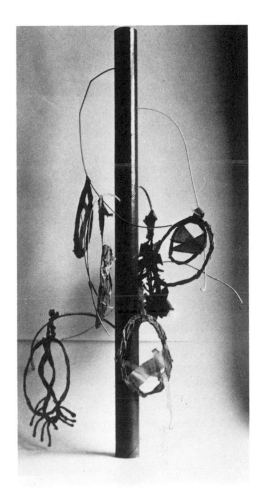

Fig. 18 *Maypole* by Deirdre Philipps

The little construction shown in colour (fig. 24, page 33) was made from wooden coffee-stirrers from a cafeteria (or ice-lolly sticks). They cost next to nothing (even if bought), are easy to handle and have many possibilities. In playing about with them, the movement of birds suggested itself to me — the spreading of wings, the swooping down and rising up in flight, the feathery quality that could be achieved by spacing the little sticks.

I laid the first lot of sticks (fig. 19a) on the table and on each I put a blob of fast drying liquid cement (the kind that takes about ten to fifteen minutes before it will suddenly bind); when ready, I put them one over the other, crossing them as in the diagram. I then laid out the next batch (b) and found that I could get a more even rhythm, and also make it simpler, by putting a blob of glue in the centre of each stick; this still enabled me to attach the end of one on to the middle of another, and so on, with variations. I liked the even rhythm of the first arrangement and the more ruffled appearance of the second, so I made a third one on the centre-blob principle. Since these flat sticks are quite thin, the 'birds' are almost two-dimensional — but not quite; the overlap of a dozen or so sticks gives them a little thickness. The three-dimensional effect is only fully achieved by combining the three shapes and balancing the tilt of one plane against the others, and by spacing them so that they are the right distance from one another. (To get the right tilt, you can simply experiment by holding your hands, or a piece of cardboard, this way and that.) Once the relative positions were determined, I marked on each piece the point and the angle of the support and drilled little oblique holes into them. I glued thin brass rods into the holes; but the white 'bird' had no point at which it was thick enough to do this, so I bent the end of the rod and glued it on. Having painted my shapes, I drilled three holes into a wooden block and glued the rods into them. This piece looks best displayed against a light

a

b

Fig. 19

wall where the play of shadows behind it is part of the whole effect.

One of the household waste materials most popular amongst students, designers and amateurs is the egg box. Being mass-produced and so cheap-looking, it would not seem a particularly attractive material, but it must have something to stimulate the imagination of so many people. So here are three examples of ways in which it can be used.

Fig. 21 shows you, first, the raw material, in this case a shiny, smooth egg carton in pink Styrofoam; then how it has been cut and put together, which is both simple and ingenious. The moulded parts of two egg cartons have been used. First, they were cut in four with a razor blade as shown in fig. 20a; the lengthwise cut will leave a wavy edge as in (b). Two straight edges are then joined with Scotch tape as shown in the right-hand top part of fig. 21, where three parts have been put into position for joining; a fourth part will be added underneath the two on the right side and fixed on in the same direction, allowing the whole structure to curve. The same procedure is repeated for the left half, and then both parts are glued together in the centre, as shown in the lower half of the picture. This construction is called 'Home' because in an allusive way it suggests shelter and warmth — the pink colour is intensified by the multiple overlap and glows out from the inside; the outside is shiny and reflective; and the whole is composed of many units like the rooms in a house. The piece has a fine sculptural or, rather, architectural quality.

Fig. 22 shows the other, blotting-paper variety of egg carton. Here, too, the lid has been discarded and only the sculptural, dome-shaped pieces have been used. They are painted black and white (the colours are reversed on the other side) and are divided by and fixed to the transparent panel of perspex (Plexiglas). The interesting thing in the use of perspex or glass is that it is both

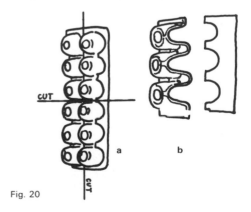

Fig. 20

there and not there at the same time: because of its transparency it loses visual presence, yet its reflective qualities, and our consciousness of its tactile character, make us aware that it is there. This ambiguity is, I think, well exploited here. The transparent panel has feet — it may have been a stand for something else which has been adapted for this new purpose. It has been pushed into the slotted black wooden base. The lower three egg cartons have

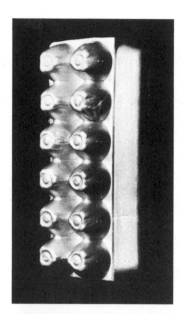

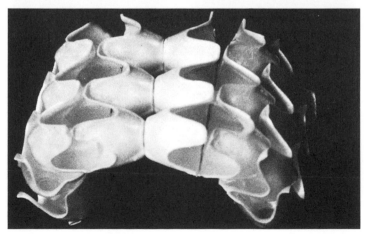

Fig. 21 *Home* by Pat Murtagh

been glued on either side of the panel; the three upper pairs have been tied on with a piece of clothes line, black on this side, white on the other.

You can see how technically simple this piece is -- yet the idea is interesting. It holds together a conglomerate of various textures and motifs by good design. The forms are bound together, literally, by a line, making a visual pun.

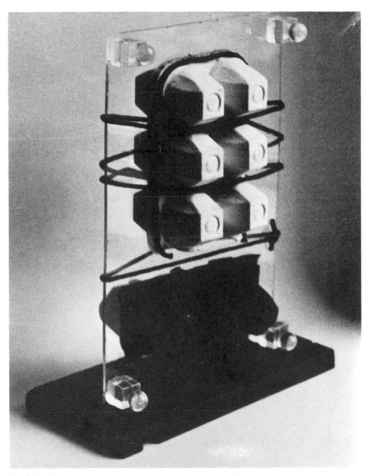

Fig. 22 Construction with egg boxes, by Leonia Abrams

The relief panel in fig. 23 also includes egg cartons, this time with a lid. The other objects are all kitchen discards — yoghurt jars, a stawberry box, all sorts of empty tins and their lids.

The base, which is part of the construction, is softboard (made of compressed paper pulp). The arrangement has been carefully considered and pondered over — oblong and cylindrical shapes balance each other, the free spaces between them also being part of the design; the focal point immediately attracting the eye is our old egg carton: but, while all other forms are closed, this one is hollow — the one negative counterpoint. The dark circle near the bottom shows where the yoghurt jar standing underneath the panel has come off.

The whole relief, including the board, has been sprayed with

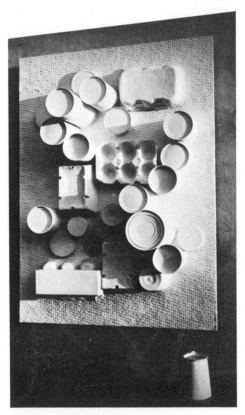

Fig. 23 *White Panel* by Håkan Carheden

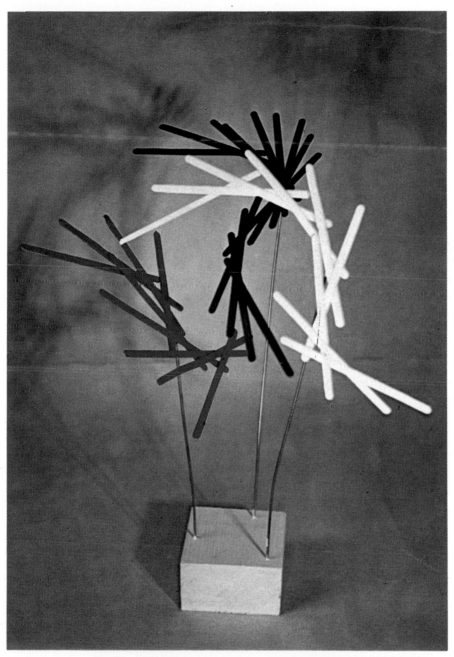

Fig. 24 *Swooping Birds* by the author (see page 28)

matt white paint. It has then been mounted on a larger plywood board, with little blocks separating it from the plywood so that it stands well away from it; the plywood is also made to stand a little away from the wall on which it hangs.

Just as kitchen discards will serve as a pool of useful materials for making constructions, so will the tool cupboard and the collected bits and pieces from electrical equipment, dismantled torches, radios, alarm clocks which have given up the ghost, old pieces of flex (electric cord), and indeed any piece of discarded domestic machinery. Parts of abandoned bicycles, agricultural machinery and motor cars will supply plenty of material for larger work — work which can be done out of doors or in a garage or proper workshop. This is a fascinating field but almost all these larger metal constructions need welding equipment and technique — so I shall confine my descriptions to smaller items which can be done without any specialized knowledge or facilities.

Fig. 25 shows you an almost calligraphic little construction made of discarded bits of domestic machinery. Fixed to a plain wooden board you can see the case of an alarm clock; issuing from it are pieces of flex (electric cord), connecting the various components of this new 'nonsense' machine. On top you see the spring, to the left the blank clock-face; the glass is hung on the right-hand wire and here and there are some of its wheels — in fact there are very few things that have not come out of that disembowelled clock. Two pieces of thicker wire support the delicate structure, and as they bend or are moved by a puff of wind it gives off a little tinkle. In the photograph you can see strong shadows thrown on the wall behind it — they almost duplicate the design so that it is hard to say which is which. The components are fixed to one another by thin wire or suspended by nylon thread; bent-over nails or staples attach it to the base.

Office discards form the chief ingredients of the piece in fig. 26. The lid of a cardboard box is used for a base; onto one corner is glued a piece of balsa wood, next to that another, longer stick to the top of which is glued a transparent plastic disc; a thicker piece of perspex (Plexiglas) is glued to the two uprights on the right, supported further along by a yellow transparent tube, the top of which is seen on the perspex bar. Oblong strips of cardboard connect the right-hand uprights, form a bridge above the perspex bar and are glued to the upright cardboard strip on the left; the

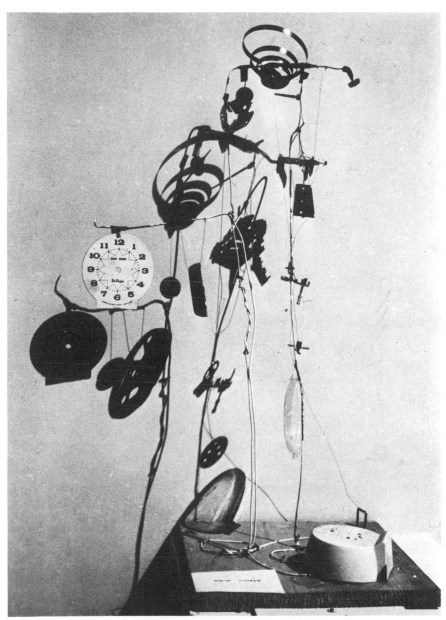

Fig. 25 (Courtesy New York School of Interior Design)

vertical piece with the six circles is a child's plastic palette, glued to the upright cardboard. Resting on the upper bridge is a sail-shaped piece of corrugated cardboard, glued to an angular vertical cardboard upright, and onto this are glued three inner spools from rolls of Scotch tape.

The piece was put together in roughly the same order as I have described it. It contains a combination of different elements, but mainly oblong and round shapes; the sail is the 'odd man out' providing surprise and preventing monotony. The colours are white and light grey and the natural colour of the wood.

When bending cardboard, you should take a sharp blade and first score the board on both sides, following a straight edge; accuracy is essential.

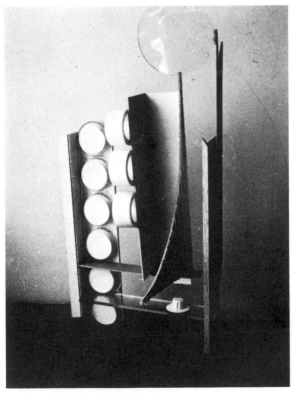

Fig. 26 Construction by Bill Amidon

Found objects

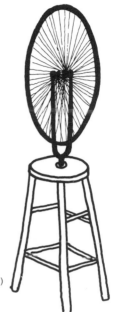

Fig. 27 *Assisted Ready Made* (1914)
after Marcel Duchamp

In folk art and craft all over the world there is an old tradition of using locally found materials for making souvenirs and for decorating objects for everyday use. In many a coastal town or fishing village one can see little pictures made from seaweed, shells and starfish, or boxes decorated with stuck-on shells and bits of driftwood or tree-bark. As an extension of weaving and embroidery, scraps of material have traditionally been used for patchwork and for appliqué work. And many an elephant's foot from India has been turned into lamp stands, bottle holders, ashtrays and the like. But the use of materials such as those mentioned in my list (page 9) for creating objects of art, was quite revolutionary not so long ago. The idea behind their use is twofold: first, the artists who introduced and propagated the idea wanted to bridge the gap between a selected few who celebrated 'high art' — the connoisseurs and collectors — and the mass of people for whom such art was of no particular concern; and second, it was a way of saying that no matter how humble and ordinary a material is, a work of beauty or interest could still be created from it. This attitude also tries to bring art into line with present-day technology by making use of the mass-produced article and industrial materials and products.

The first revolutionary steps in this direction were taken by Marcel Duchamp who took an ordinary industrial product, a

bicycle wheel, and put it on a pedestal (fig. 27). The pedestal was a kitchen stool, satirizing the whole concept of 'high art' in one blow. The fork with its wheel was screwed upside down onto the kitchen stool which was painted white. It was exhibited as *Assisted Ready Made* in 1913–14 — an act of social protest against the bankruptcy of a society whose values had been leading to World War I; it is a statement of 'anti-art', since art had been the prerogative of those privileged few whose values were being fought and contested.

The original bicycle wheel has been lost, but since Duchamp's idea in the first place had been that this was something that any-body could do, several replicas have since been made.

Although the found object (originally the French 'objet trouvé') is widely used today, it nearly always undergoes a transformation in the hands of the artist, who thus makes it his own creation.

One of the pioneers in the use of the found object as raw material for his work was Picasso, the great genius of our times. He took the handlebar of a bicycle, put the saddle on it — and there was the sculpture of a bull's head (fig. 28). True, he later had it cast in bronze — partly to preserve it, partly to accentuate its identity as a true piece of sculpture. Nevertheless, this was a

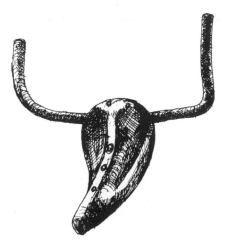

Fig. 28 *Bull's Head* (1943) after Picasso

revolutionary act, one of irreverence towards traditional values and media. Picasso took two of the most trivial objects of everyday life and by combining them in a different, non-functional way, he created a new whole out of them. He probably saw the old bicycle standing in the yard one day and, not looking at it as an object of use but simply as form and shape, he suddenly 'saw' the bull's head in it. No technique, no craftsmanship was required — only vision.

My next illustration shows a simple stone, a flint, picked up on the road: as it lay in the artist's hand he saw it resembled a sitting figure — without a head. He then set out to find the round stone needed for the head. Once he 'saw' the figure, the rest was simple: drill a hole into the top of the 'body' and one into the 'head', cut off a piece of metal rod and glue the two together with instant glue, supporting it until dry. It is a convincing little sculpture. (Fig. 29).

The rustly old plough on the wall (fig. 30) is a found object taken straight as it came. It was put there by a group of young Sardinians who are turning their village, an agricultural centre, into a 'città museo' — a museum town; they believe that works of art should not be inside museums but out of doors, accessible to

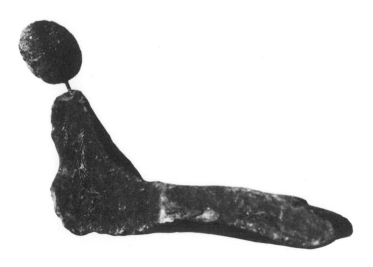

Fig. 29 *Flint Figure* by Dr Ernest Shaw

all and so a part of community life. This plough represents an element of peasant tradition, a symbolic record of a living society. It also becomes a piece of decoration: see how beautifully it is placed on the wall, how the elements of its design — the straight lines, the curves, the diagonals, the larger area of the seat — are played off against the rough texture of the large, regular stones of the wall; observe also the fine linear design of the delicate branches overhanging the wall.

In sharp contrast to the old plough, fig. 31 shows a piece consisting of many identical units, arranged to form one whole unit. The material is as new as that of the plough is old: the rings are plastic bangles bought in Woolworths, intertwined and interlocked to such an extent that the eye cannot follow their linear

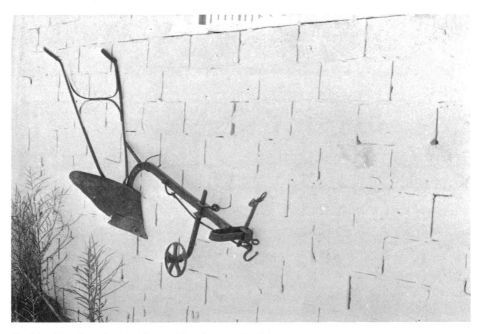

Fig. 30 *Plough* by the inhabitants of San Sperate, Sardinia

course. Their density is greatest near the centre and the odd loop swerves out to form a gay arabesque. The piece has been set to rest on a thick slab of clear plastic; note how the three bottom rings lean down from the slab to the table. Where the mass of rings is densest they hold each other in place – the looser ones have been glued to each other so that the piece is stable. It has then been sprayed with plastic paint and, when thoroughly dry, glued to the slab.

Whereas the plough on its wall is static and serene, the plastic rings are dynamic and form a continuous movement.

Constructions, as you will see, can be real works of art – it is then often difficult, and also pointless, to distinguish them from sculpture. A true artist will handle the most unlikely experimental

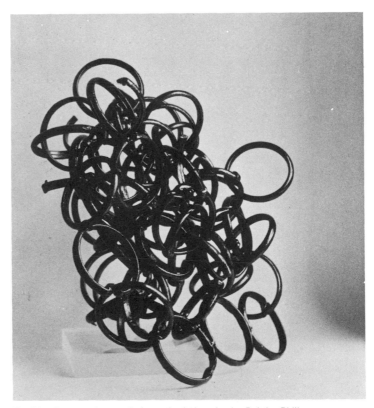

Fig. 31 Construction made from plastic bangles by Deirdre Philipps

materials with a sense of form and appropriateness which will make them subservient to his vision, be it playful or serious. Amateurs have to put the accent on the playful and experimental aspect of the work, on the doing rather than the finished result, until eye and hand are a well-established team. But even with professional sculptors the aim is not necessarily a serious work of art — it may be just 'a thing' (namely, a construction) to express a mood or a polemic, a social comment or protest.

The bashed-up car in the illustration on page 52 — another 'found object' — is just such a comment. It forms the greatest possible contrast to the old plough and the primitive agricultural environment, the little Sardinian village, where it has been hung as a cautionary symbol of our mechanized society. Yet is does not hang there untouched by the artist's hand — he has integrated it with the wall by the simple device of the red stripe painted boldly over both.

Fig. 32 shows yet another way of using found objects. These are old stovepipes (scrapyard material) used to form one monumental whole on the central piazza (the village green) of San Sperate in Sardinia. The pipes have hardly been manipulated at all, but left much as they were found. The interest lies in the grouping of half a

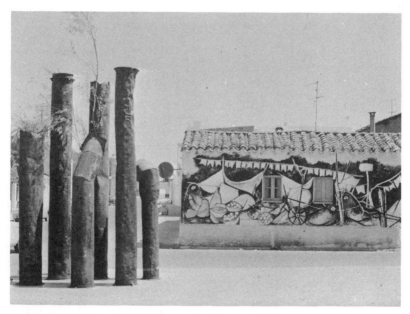

Fig. 32 *Composition of Vertical Elements* by Giuseppe Sciola

dozen similar units, their unequal length and indentations; just enough variety is achieved to prevent monotony by using the two angular pieces. The branches sticking out at the top are not part of the original construction — they are left-overs of decorations for a village festival. The vertical design forms an interesting contrast to the low houses surrounding the open piazza.

If you want to make an impressive outdoor construction, you may find inspiration from this rather monumental piece (fig. 33). It is made from a wooden beam (possibly a railway sleeper), iron rimmed wheels, and white paint. It stands over six feet high and is made entirely of found objects. It is called *Moon 4*, presumably because the moon is painted on in its four stages. The 'I' at the bottom is the artist's initial.

The design is as simple as it is effective: an oblong block contrasted by two sets of circles, one flat (the moons), one three-dimensional with linear effect (the wheels), occupying four of six equal spaces. The lettering is stencilled as on wooden crates. The wheels could be fixed or turnable.

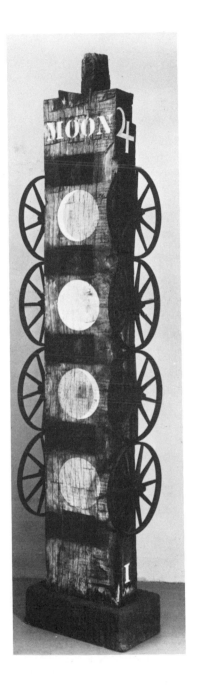

Fig. 33 *Moon* (1960) by Robert Indiana. Assemblage of wood beam with iron-rimmed wheels and white paint, 78 ins high, on basis 5 ins × 17 $\frac{1}{8}$ ins × 10 $\frac{1}{4}$ ins. Museum of Modern Art, New York (Philip C. Johnson Fund)

Technically it is so simple that there is really nothing to say. The idea is everything, the execution practically nothing. Given the vision and thought behind it, anyone could have done it.

This is really the gist of what I am trying to convey: your constructions are lying in the road, waiting to be picked up; all you need is a fresh eye that will begin to see hackneyed things in a new context, divorced from their conventional meaning — to see them as form and shape and colour and to use them as elements of design in new and different relationships.

Natural found objects

Now from the monumental to the minute, from man-made found objects to those one finds in nature. On one of my rambles I found an unidentifiable object, perhaps a seedpod or a hollow oak apple, nicely speckled and wrinkled. I had it lying on a large tray full of various collected items, until one day I saw it could make a bird by putting it on a fine rod at the right angle (fig. 34). It makes people smile when they see it on my shelf.

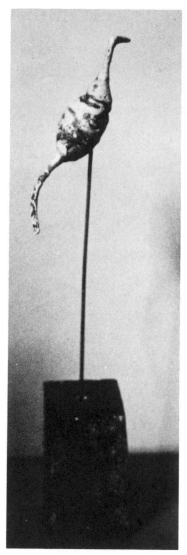

Fig. 34 *Bird* by the author

When trying to find objects for your collection of possible materials, you may be more stimulated by a slightly less familiar environment than your habitual surroundings; what you see every day is hardly noticed, but newness sharpens the perception and stimulates the imagination. A town dweller going to the seaside, for instance, will notice all sorts of marvellous materials taken for granted by the local population — a piece of driftwood or a gnarled root bleached by sun and wind may be enjoyed for its own curious shape and could perhaps be mounted on a block like my own little bird. Or you may 'see things into it', associate its form with something else, and by transforming it into what you see in it, you will have created something new and personal. This twist which turns an object into something other than what it is can be of many kinds: you can use colour, or sandpaper a rough surface down, or alter parts of it by chipping away with a knife; or you can combine it with other materials, either similar or contrasting. There is no limit to invention — but the capacity to invent lies essentially in your ability to see things in a new way; to disregard the well-worn context, particularly the utilitarian one, and combine components in a contrasting, paradoxical and even nonsensical way.

Pebbles have been used for several hundred years to make ornamental mosaics. In the gardens and courtyards of the royal palace in Genoa, for instance, there are the most beautiful heraldic and geometrical floor-mosaics made from pure black and white pebbles of a kind I have never been able to find anywhere myself.

However, a lot can be done with the subtly-coloured pebbles found on our own beaches. The pebble-lion (fig. 36) was made from these. Collecting the most beautifully coloured and interesting looking stones was a weekend project for everyone, including the children; basketloads were carried home for further selection. The projected site was the dining-room fireplace. First all the loose paint and plaster was knocked off, and then the outline of the lion was drawn in black crayon, from rough sketches; then work began in earnest. A fast-drying plastic cement was used to fix the pebbles to the wall. It was necessary to begin at the ledge above the opening of the fireplace, to prevent the stones slipping before the cement was dry. The work had to be built up from the bottom, doing a bit at a time to allow the cement to dry before going on to the next bit. To visualize the effect, sections of

the work were laid out on the floor, before transferring them to the wall. My photo only shows the main part of the mosaic — in fact it goes down to the floor on either side of the grate. The sides also had to be built up from the floor.

Pebbles look much brighter when wet; the same effect can be achieved with dry stones by varnishing them with a clear varnish, although this tends to give them a slightly more commercial look. The artist who did the lion preferred the subtle and subdued effect of the untreated stones, which gives the piece the faded character of an ancient mosaic.

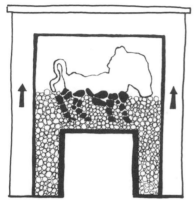

Fig. 35

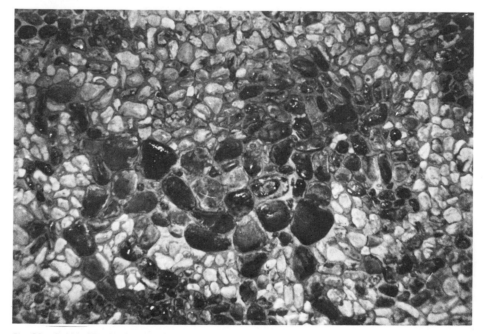

Fig. 36 *Pebble Lion* by Antonia Hunt

Pebbles also combine well with other materials: they have been traditionally used by craftsmen in East Suffolk for laying down paths and floors in combination with brick, forming ornamental designs; and the Japanese have been using them for centuries in designing their gardens and building ornamental walls. When chipped in half, the shiny surface of flint contrasts with the matt rounded one of pebble and flat stone; extensive use of this contrast has been made on the outer walls of the flint churches in East Suffolk.

In the next illustration (fig. 37) you will see pebbles used very differently in combination with other materials, forming a loose dream sequence. The top left-hand piece represents mother and child in a very archaic, Easter Island sort of way. Technically it is very simple: holes were drilled (with an electric drill) into the stones, and pieces of steel rod were then glued into the holes with epoxy adhesive.

The construction below, left, is made in the same way, except that the base stone has first been glued to a wooden block before drilling the holes and inserting the steel rods. It is a very carefully considered piece, balancing the shapes and sizes of the stones, the angles at which they are fixed, and the lengths of the connecting rods and the points of entry and exit of the rods from the stones — here nothing is left to chance, and the result is rhythmical and of considerable spatial interest.

The construction on the right, above, is similar in technique but very different in spirit. It has a truly savage, primitive agressiveness, about as tender as the bite of a spider. The stone was found cracked and was then split along the crack; both pieces were used. Nails and screws were glued on to each piece and they were connected to each other by a short piece of steel rod; a large screw stabilizes the two parts against each other. Holes were drilled into the large stone and the wooden block, and the supporting steel rod was glued to them. The size and colour of the block and the length of the rod are so chosen as to be part of the whole piece.

The piece below, right, is a curious bit of fantasy, part dream, part fairytale. Three flat stones appear to be supported by (or resting on) two eggs. The pebbles are untreated but the eggs have been blown; holes have been drilled into the stones and two dowel rods, slightly longer than the eggs, have been pushed through the eggs and glued to the stones. The eggs are left hollow,

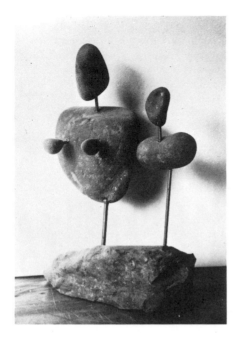

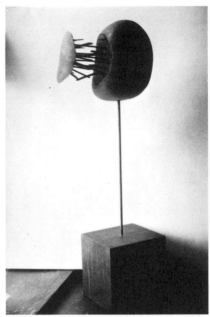

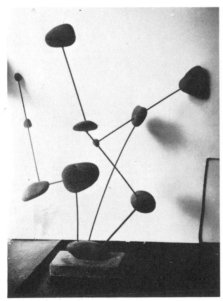

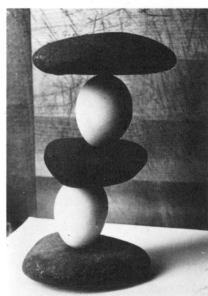

Fig. 37 *Dream Sequence* by Dr Ernest Shaw

but of course, if one wanted to preserve such a piece for any length of time, it would be better to fill the eggs with plaster — either plaster of Paris or cellulose plaster. Notice how the lower egg rests left of centre on the bottom stone, the middle stone left of its centre on the lower egg; the upper egg is placed slightly to the right of centre on the middle stone and the centrally placed top stone protrudes over all. This makes it look a bit like a mushroom; the shift of balance to the right gives the piece its curiously insecure and irrational appearance.

Both Dr Shaw, who made the four constructions in fig. 37, and his wife Emily, have a peculiar preoccupation with eggs; they use blown eggs in connection with rods, cane, wire and wood — all in their natural colours. I have seen a charming egg-mobile and a little construction made from twisted wire and an eggshell filled with watch-parts. Watch-parts are another of their favourite materials, often put to symbolical use as shown next (fig. 38).

This piece is made from a small block of wood (for the base),

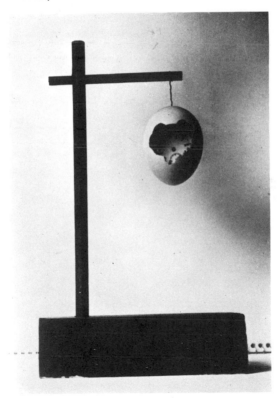

Fig. 38 *Enigma* by Emily Shaw

and two dowel rods, the smaller one slotted through a hole drilled in the bigger one. The egg is blown, and broken open to reveal on one side a watch face without hands, and on the other some of the little wheels from inside the watch. When the egg was opened it was filled with a lump of plaster and, while the plaster was still wet, the watch parts were put in place. A thin wire was attached to the watch face and pulled through the hole in the top of the eggshell and, when firmly set, the eggshell was attached to the 'gallows', which was painted black to give it a macabre look.

The piece is called *Enigma* because it muses, in a visual way, on the riddles of life: what is time? the beginning of life? what is death? It is, in fact, an important existentialist piece, despite its small scale.

Natural found objects form the chief ingredients of the decorative panel in fig. 39, but they are interspersed with man-made ones and even a few discards. A piece of cardboard is covered with a neutral-coloured cloth of rough weave on which all the rest is stuck with glue. A panel of this kind can also be called a montage or assemblage, because the component parts are assembled and mounted on a flat surface. Notice the way in which contrasting forms and textures, shapes and colours are assembled, and the cast shadow which indicates the height of the relief. I can only list the objects in it and hope you will be able to identify them from the photograph and be stimulated to make your own assemblage:

glass marbles set in plaster	driftwood
two gourds	a thistle
a slab of marble	dark cork
a piece of mirror	pieces of rug (red, pink and orange)
the glass lid of a coffee jar	a glass paperweight sprinkled with
a copper scouring pad	black paint
styrofoam balls, some halved	

The panel is bound with black tape.

For a description of fig. 40, called *Dog I,* I cannot do better than to quote the artist, Bonnie Thomas, who created it: 'To do this, I severed numerous pussy willows in half and adhered them with Copydex (Elmer's or Sobo) glue to what was a piggy bank in plastic fashioned after an English bull dog. The texture of pussy

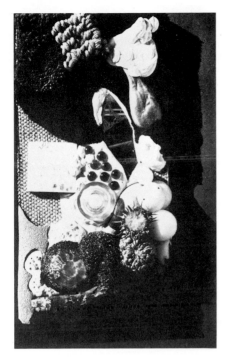

Fig. 39 Assemblage (Courtesy
New York School of Interior Design)

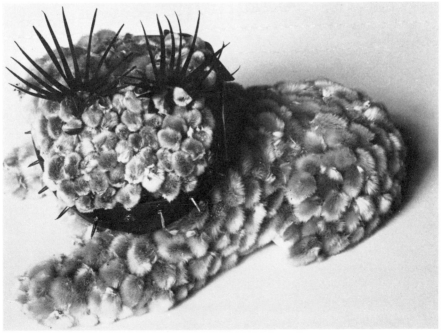

Fig. 40 *Dog 1* by Bonnie Thomas

willows seemed the logical solution for covering the animal as the effect wanted was to have it very touchable — and at the same time untouchable. This of course I did by covering the collar with very sharp carpet tacks. Oddly enough everyone who sees this creature immediately wants or tries to touch it.' Wouldn't you?

Fig. 42 is a composite piece consisting of seedpods, a pebble, paper, cane and three sticks of wood. The base is slotted wood into which the sticks are glued. The sticks, painted black, are important elements of the design but also serve as support for the fragile parts. You will see one seedpod split, and three similar shapes made up from cane and translucent paper; together they form a kind of blossom, incorporating flower and fruit. The bits of cane are like tendrils — graphic arabesques — on which sit the other round shapes — part foliage perhaps, part flowerheads? The large one may symbolize both flower and sun; it is cut from trans-

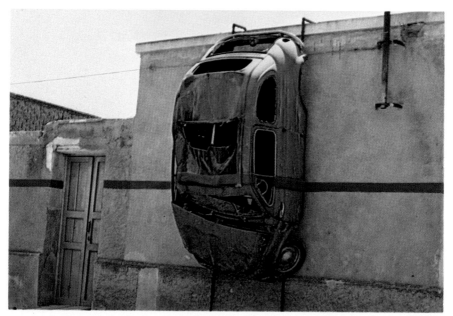

Fig. 41 Smashed-up car on wall of Sardinian village, by Rainer Pfnürr (see page 42)

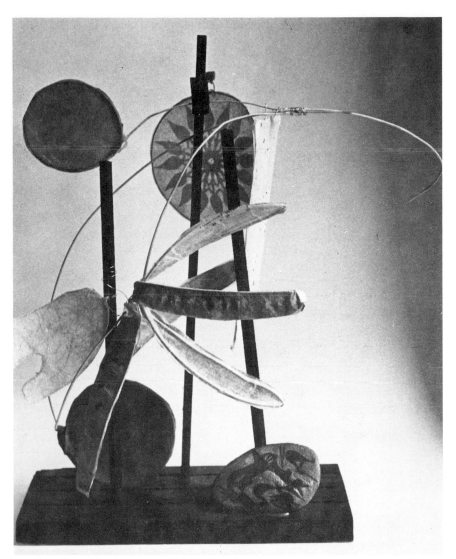

Fig. 42 Construction by Leonia Abrams

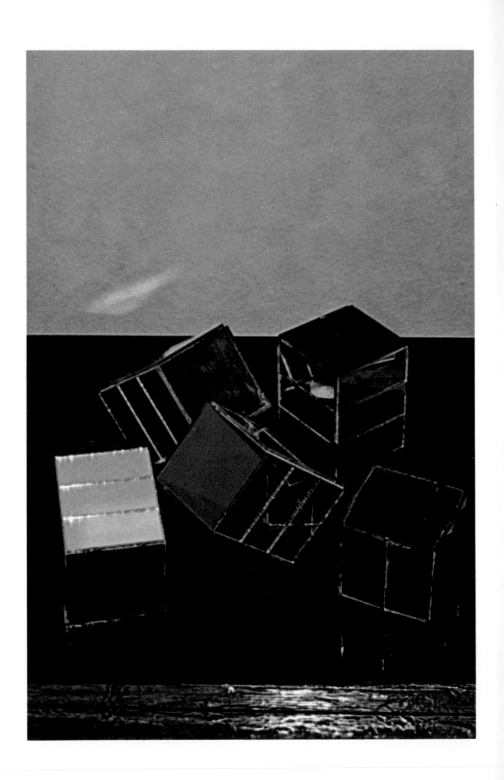

lucent printed paper. The palette shape is made from Chinese rice paper stuck into bent cane (the cane has to be soaked before bending — see page 27) and the pebble has a black design painted on it. The colours are very subtle, subdued pinks and buffs. This is a very delicate and lyrical piece.

Here (fig. 44) is a panel in very high relief: the base is hardboard (masonite) on to which are glued, or screwed, various found objects, brightly painted in red, yellow, pink, blue etc. Above the glossily painted piece of driftwood, on the left, are the artist's initials A O and some other lettering used decoratively; in the centre is a tusk projecting right out of the panel, and above on the left a pair of antlers on which buttons have been placed as eyes; there is also a tortoiseshell, a shell, a bunch of grasses, part of a shopping basket, a mask, nails, a fish's jaw and teeth and a number of other objects. The baseboard has been framed so that all these objects appear to come out of a picture. It is a striking piece now in a big private collection in Paris, and it is very skilfully done; but there is nothing in it that cannot easily be collected or assembled, and anyone with a fresh eye and a few basic tools could make a construction of this kind.

Fig. 43 *Mirror Constructions* by the author (see page 56-8)

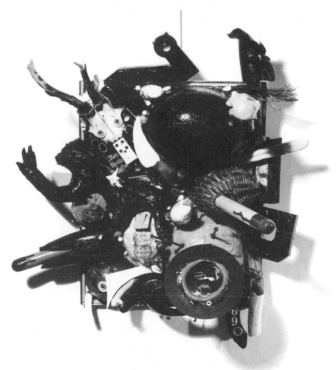

Fig. 44 *Lost/Found* (1969) by Ossorio, 18 ins × 25 ins

Glass

I am going to treat glass, in the context of this book, as a found object, as a material which can be a component of constructions combined with other materials or used by itself, either as it is found in kitchen, laboratory or junk yard or as offcuts (scraps) from a glass or mirror shop. We are not here concerned with designing glass or decorating it or making stained glass panels. The construction shown in fig. 45 is a very original piece of work. Its elements are the lenses from discarded spectacles, mounted with a clear glue on three panes of window-glass set one behind the other into slots in a simple wooden frame made specially for the purpose. Among other things, it shows how well worthwhile is the collecting of discards. The little dark circles are tiny mirrors stuck on here and there. The whole thing sparkles and scintillates in the light.

The mirror construction shown in fig. 43 was inspired by the metal piece shown opposite. Welding is beyond the scope of this

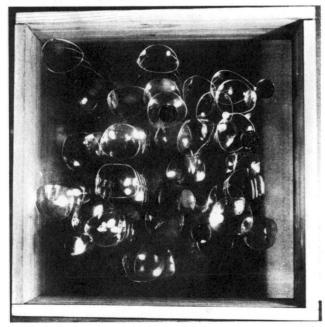

Fig. 45 *Lens Construction* by Ken Partridge

book — but I found this construction interesting from more than one point of view and so I made a variation of it in glass. The five components of the metal piece are permanently fixed, but in making a similar construction, the blocks can remain separate to allow for re-arrangement whenever the spirit moves you. Different effects can be achieved by using different bases for display — dark velvet will transform it as much as will a bright shiny surface or reflecting surface such as polished metal, or even another mirror. In fact this construction does not include a base; it can be put anywhere it looks good, or stored away to make an 'instant sculpture' at another time. Another interest lies in the dual character of the component parts: they are at the same time bulky volumes and hollow structures with very thin walls; the interpretation done in mirror glass accentuates this further, because the light reflecting from them plays all sorts of tricks with volume and solidity.

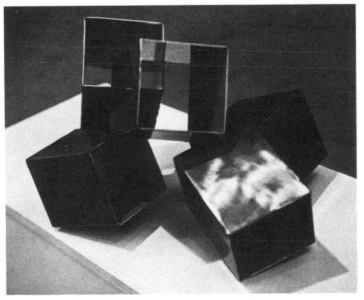

Fig. 46 Steel boxes by Ann Casimir

Fig. 47

The sectioned mirror, shown in the background of fig. 48, is much used commercially and is available in builders' supply stores. I cut strips from it four times the size of one facet of the required block; a blade will easily cut through the flannel lining on which the mirror is mounted. Next I painted this lining with fairly dry paint — one strip black, one red and two blue. The two right-hand forms are mirror all round. The paint must not be runny or it will seep under the glass. When the strips were dry I folded them and put contact (instant) cement along the edges A and B as in fig. 47, letting it dry until tacky, and then joined the edges, holding them in place with masking tape until firm. In manipulating my blocks I found that some of the right angles would give way, so I had to fix them with glue in the same way.

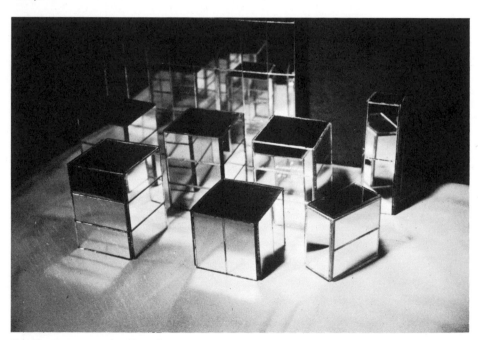

Fig. 48 Components for *Mirror Construction* by the author

This hanging construction is made of glass rods from a chemical laboratory. The artist, Dr. Bauer, is a nuclear engineer who one Christmas rigged up a mobile decoration with fish and a duck and so on. His seven-year-old son rather swept it aside with the remark that it was perhaps a trifle on the realistic side. This stung the father into action and the duck has since been replaced by the glass rods.

The rods are glued together and hung from the ceiling by nylon fishing-tackle thread, so that it swings in the breeze.

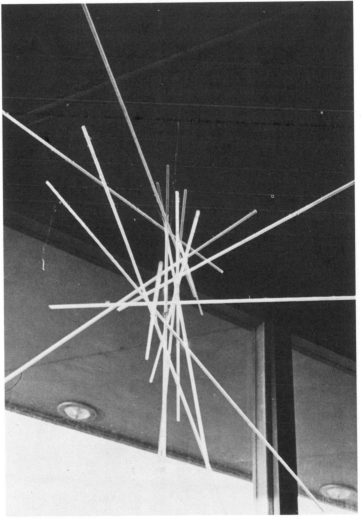

Fig. 49 Glass rod fantasy by Dr S. G. Bauer

This type of glass rod can also be shaped by heating in a gas flame and bending it gently while hot.

You might like to try making a relief panel with small glass objects such as jars, bottles, stoppers, pieces of mirror glass, and glass marbles. They could be set in plaster provided they are not too heavy. You can make a glass-collage, the modern equivalent of a stained glass window, by sticking on to a sheet of glass, with transparent glue, all sorts of broken bits of coloured bottles, glass buttons and the little pieces of coloured glass often to be found amongst the pebbles on the sea shore. Anything transparent or

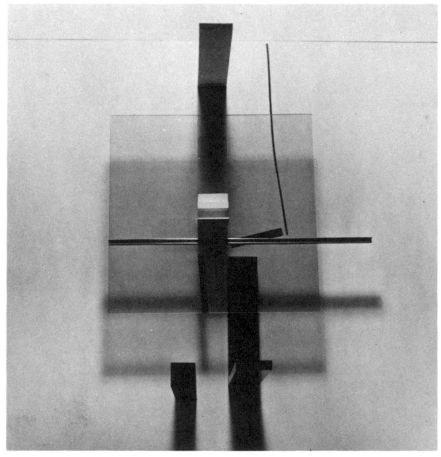

Fig. 50 *Projective Construction in black, white, silver and mahogany* (1965) by Victor Pasmore (48 ins square)

translucent can be incorporated. The finished piece can be glued to the window or edged with plastic or metal edging and suspended in front of a source of light.

Plastics such as perspex, or Plexiglas, are materials to be used in similar ways to glass; but again, subject and technique are rather beyond the scope of this book. I shall only show you one or two examples to whet your appetite: one is the 'Projective Construction' by Victor Pasmore (fig. 50); so called because its components project out of the panel. The sheet of perspex is quite a distance in front, as can be seen from its shadow. The narrow pieces are black, white, silver and mahogany. Screws and glue are the technical answer. The design is severely rectangular but the three oblique strips give it movement and a certain liveliness. It is hanging on a wall.

The Pasmore piece is a highly professional job, both in design and precision of execution, but a little panel like the one in fig. 51 could be made by an amateur or beginner. Small strips of thin brass foil are glued onto a sheet of perspex with transparent acrylic glue. In order to get the strips even, mark out parallel bands, with a felt pen, across a length of foil; then roll it up to get the curvature. Cut off the bands with a pair of scissors and from them cut the narrow strips. The actual gluing is a delicate job and needs a light touch – but nobody without a good deal of patience would undertake such fine work.

Note the movement achieved by reversing the curve of the middle band and how the uneven, wilful twisting of the little strips results in a glittering reflection of the light. Note, too, how the outer circle is complete at the top and bottom of the panel but is cut off on both sides, giving the design a personal touch.

The panel is slipped into a slotted block of wood and is displayed against a light wall on which its shadow makes further play. It would be equally suitable, if you preferred, to mount a panel like this on little feet of either round balls or cubes of plastic – they can be bought in artist's supply or hobby shops (see fig. 22, page 31). Glue the bottom corners of the panel between a pair of these little cubes. There is a special solvent on the market which dissolves and instantly glues perspex together.

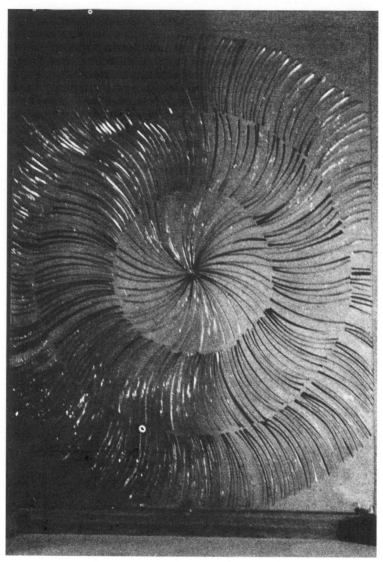

Fig. 51 *Suncircles*. Studio Ken Partridge

Metal

Metal in any form is an unending source of material, from the finest wire to the coarsest iron girder, from a rusty nail to polished steel; brass and copper foil, thin sheets of aluminium which are easy to bend; rods of all lengths and diameters, chickenwire, perforated metal sheets; and, last but not least, anything that can be found in the junk yard, where there is a rich supply of discarded metal objects, once proud products of our technology, now forgotten derelicts.

Metal surfaces can be joined in various ways. Heavy jobs have to be welded, lighter ones can be brazed or soldered — but these methods are beyond the scope of the beginner, and a lot can be done with simple gluing, using one of the modern glues already mentioned.

Fig. 52 shows a wire horseman done from ordinary thin wire. The wire is used continously without stopping, as in drawing without lifting the pencil; it is pulled backwards and forwards, twisted and curled and bent, but never cut. Look at the tail or the head — this uninhibited energy gives it great dynamism. You will see that parts of the rider (who is disproportionately big) have been thickened in order to accentuate them; this is done with a soft plastic metal paste (Sculp-Metal in the U.S.) which hardens as it dries. It can also be done by using thick paint. This is a three-dimensional piece, although in a photograph it looks linear. The horse's legs are fixed to a wooden block with wire staples.

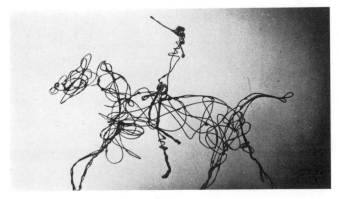

Fig. 52 *Horseman* by Dr Ernest Shaw

A decorative panel can be used as a screen. The one shown in fig. 53 is used in a fireplace, to hide an empty grate. Here little squares of brass foil are simply glued to the heads of nails driven into a wooden board. In the photograph you will see several nailheads exposed where the brass squares have fallen off. The nails are not knocked in with absolute regularity nor are they all the same height. The little squares are approximately 1in. × 1in. but they are cut out freely and a little haphazardly so that the shapes and sizes vary; when glued on many of them overlap or tilt. All this contributes to the delightful play of the light reflected from it. The sheet of brass foil has to be absolutely flat and should be varnished with a clear acrylic lacquer before cutting.

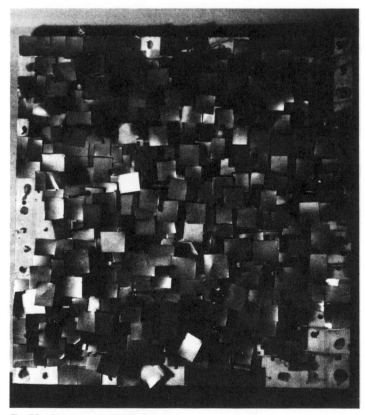

Fig. 53 Firescreen by Ken Partridge

Nails can be used in all sorts of ways other than just to join two pieces of wood, either on their own or combined with other materials. They could be built up as a relief, perhaps in a similar way to fig. 10 (page 19); or they can be embedded in plaster or modelling paste, or hammered into a board, or used for a free-standing piece as shown here (fig. 54). Although minute in size, this cross is large in scale. Here the three large nails are welded together, but instead of welding the nails you could glue them and then mount them on a block of wood, with much the same effect.

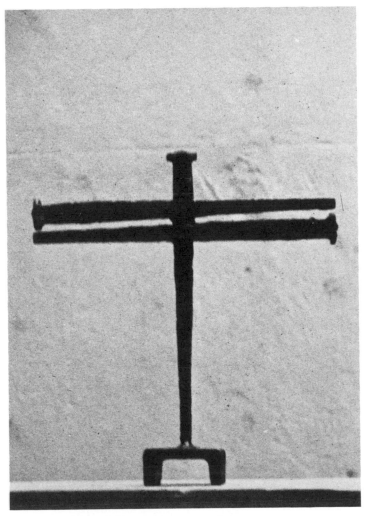

Fig. 54 Cross by Jupp Dernbach

When I started making
Medusa I had in mind to give
visual expression to a swelling
sound — but it ended by every-
one calling it the golden snake.
I took an old bedspring (from a
collection of scrap, not my
bed!) and bent it as in fig. 55
and fixed it to a board. Next I
took some glass fibre wool,
(called 'Cosywrap' in England
and Fiberglas in the U.S.)
— a wisp of it can be seen in
fig. 56a — and started to build
it up around my bedspring. To
do this, pieces of the 'wool'
had to be soaked in diluted
plastic metal paste (available
under different trade names in
do-it-yourself shops, together
with the appropriate solvents)
and wound round the spring,
allowing the material to half-
dry before finishing. When it
was firm, as in fig. 56a, but

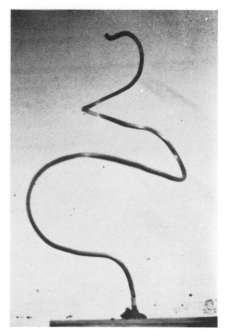

Fig. 55 Bent bedspring for fig. 56b

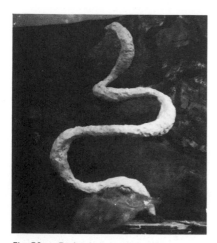

Fig. 56a Bedspring covered with
glass fibre wool

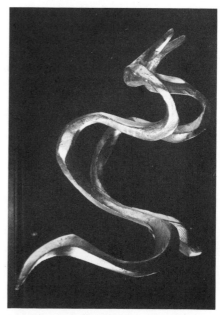

Fig. 56b *Medusa* by the author. Finished
piece lying on a mirror (see also fig. 61)

not yet very hard, I took a sharp knife and began to cut the raw piece into shape, defining the planes as they moved round the spiral, cutting a fine edge where two planes met, and alternating between narrower and wider areas. The great advantage of using this kind of metal paste is that you can manipulate it so easily and also correct mistakes, and that it can be made to look like any other material in the end. By the time I started cutting I had taken it off its base and realized that it would look much more interesting lying down than standing up. Fig. 56b shows the finished piece photographed lying on a mirror, so that you can also see its other side; but the main idea was to duplicate its writhing movement by reflection. When it was quite dry and hard I rubbed it down with fine sandpaper and filled in any little holes that had appeared in the surface. I then had it 'metallized' (electroplated) by a firm of metallizers (platers) who will coat the surface with any metal you like. Mine was done in brass and can be cleaned when it tarnishes. It can also be varnished with a clear acrylic lacquer.

My idea had been to mount it on a shallow concave reflecting surface – either a large reflector, or a concave sheet of chromium steel; but search as I would, I could not find what I wanted. In the end I cut a sheet of aluminium into a carefully designed oval (by folding a paper template to get the right shape) and polished it until it was mirror-like. This is what you see in the colour plate (fig. 61, page 71); it gives rather blurred semi-reflections and is more discreet, but less striking, than the first plan. Then I cut a plywood board to the same oval as the aluminium and made a mounting structure as shown in the diagram, fig. 57. The ends of the tray-like structure were made from reeded wood cut to shape (corrugated cardboard would do instead) and glued, edge to edge, to the board (a). They were covered on the outside with black canvas. Holes were drilled into the board, the aluminium and the 'snake' – finding the exact position for the holes was the trickiest bit – and I then screwed it all together as in fig. 57b.

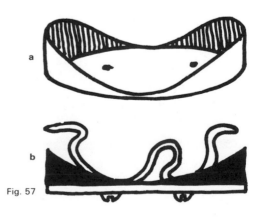

Fig. 57

Paper

Paper is, of course, easily available for anyone, anywhere. A crumpled piece of paper out of the waste basket can serve as your material just as well as a virgin sheet of cardboard. Paper may be used to work out ideas and make sketches in three dimensions, or it may be used for more permanent work. It can be used by itself or in combination with other materials; you can use white paper as it is, or coloured paper, or you can paint or spray your piece when finished. You can leave it soft and loose for an ephemeral effect, or you can stiffen and harden it by overpainting with acrylic resin, if you like what you have made well enough to preserve it.

Quite a lot of paper was used in some of the works shown in the chapter on Discards. In this chapter, I would like to show constructions made mainly or entirely from paper.

My first illustration is a black and white photograph of the piece shown on the cover, showing the translucency of some of the paper used. A length of cane, well-soaked and flexible (see page

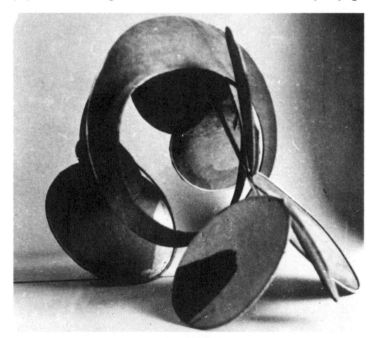

Figs 58 and 59 Construction made with bent cane and paper by Sharon Saxe

27), has been bent to form a number of circles of various sizes in a continuous line; they can be held in place with scotch tape, but this should be replaced with glue when the cane is dry. A second piece of cane was tied on with very fine wire to form the branching-off sections; the wire is practically invisible. While the cane is drying, the coloured paper can be assembled; here, some fancy wrapping paper printed in a bold design of orange, pink and mauve has been used. You can place the cane circles on the paper and draw round them, to make sure that the paper discs fit accurately before being glued to the cane. It is best to do one at a time, gluing them in as you go along, or you may get confused about which fits where. Thought must be given to matching the colours; although uniformity is assured by cutting the discs from the same sheet, the piece can look quite different according to whether plain pieces or patterned ones are chosen and to the order in which they are used.

Since this piece is flexible and has no stand, it can assume a

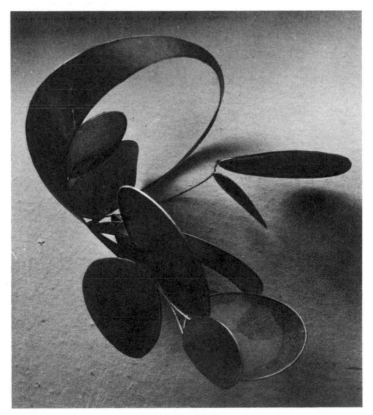

Fig. 59

great variety of forms. I have photographed it half a dozen times, and each time it looked different. It can sit on a shelf or a stand, or hang from a nail in the wall (as in the photograph on the cover), or it can be suspended from the ceiling. In every case it was charming — lyrical, rhythmical, and flowing.

I have seen another piece made in the same way but with white tissue paper, which made it look a bit like a giant Honesty plant; also it was more spread-out and was mounted to form a mobile; the use of white instead of colour, and a more severe design, made it look less frivolous, more austere.

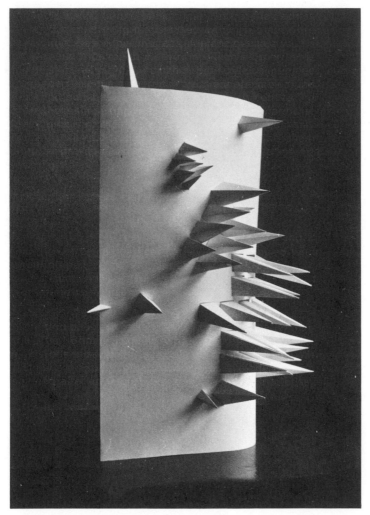

Fig. 60 Paper sculpture by Mary Jones

This technique goes back a long way: it was used in China as far back as 105 A.D., mostly for funerary rites. The principle of strengthening a thin surface (paper) by light resilient struts or edgings (bamboo, wood, balsa) is of course widely used for making kites.

Paper used by itself can be made stronger by folding or rolling; this has been exploited for making what people called 'Papyro-Plastics' in 1824 — paper sculpture, in fact. At that time paper was regarded as a respectable medium — it was not the cheap commodity it is today; up to about 1840 all paper was hand-poured, and was treated with the respect deserved by something expensive and fine.

The white construction in fig. 60 is a perfect piece of paper sculpture, its chief merits being the formal idea and the beautifully balanced and precise design. It is comparatively easy to make, although the pyramids would have to be very accurately done. A

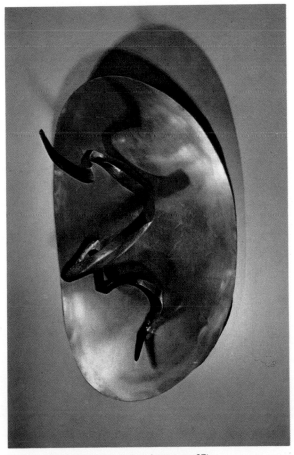

Fig. 61 *Medusa* by the author (see page 67)

sheet of thick cartridge (drawing) paper has been folded as shown in the diagram (fig. 63). The interesting and irregular form (fig. 62) is achieved by the double fold (indicated by dotted lines on the diagram), narrowing towards the top, which makes one side curve more than the other. At the open end a narrow edge is folded over and the two sides are pasted together; this leaves a boat-shaped opening at the top and an asymetrical curved shape at the bottom. Before pasting the open edges together, however, square holes have to be cut in the appropriate places (shown in fig. 63a) for the pyramids to be pushed through and secured with paste.

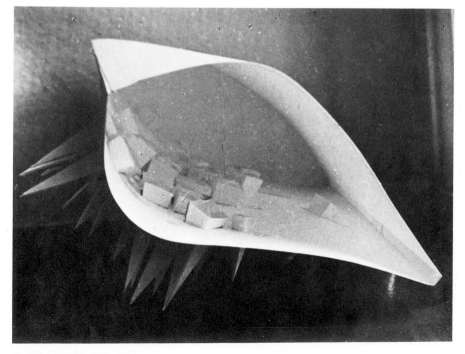

Fig. 62 Interior of fig. 60

To make the pyramid shapes, follow fig. 63b. They can vary in size. The dotted lines should be scored with the point of a knife held against a firm edge such as a metal ruler, to ensure a crisp fold. Fig. 63c shows the basic pattern for a cube. Following this principle, any shape can be made.

For cutting the paper you will need a blade in a holder or a sharp craft knife, and a pad of old cardboard or several layers of newspaper underneath the paper you want to cut. It is wise to make a few trial cuts first, to get the feeling of the thickness of your paper and the sharpness of your blade. If you want to cut along a curving line, move the paper with your left hand and keep the blade steady with your right.

The best places to buy paper in any quantity are paper factories or printers; the choice is bigger and it is much cheaper than in an artist's supply shop.

In fig. 64 I have sketched a few more ideas for use with paper

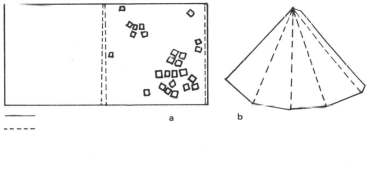

a b

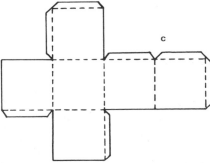

c

Fig. 63

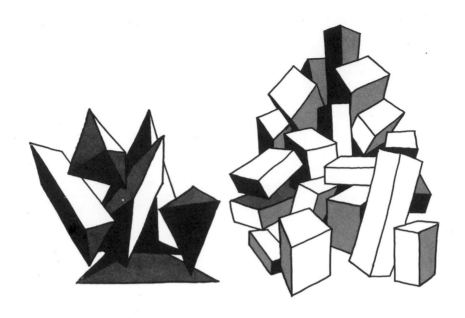

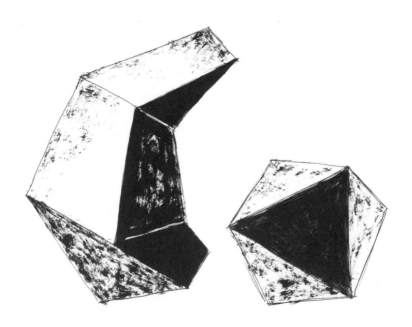

Fig. 64

or thin cardboard, following the principle shown for the pyramid.

The three-dimensional paper constructions in fig. 66 are made from one single unit: the disc. Circular discs all the same size were cut from stiff cartridge (drawing) paper. The edges of the discs were bent up to leave flat triangles of equal sides; one upturned edge was then stapled to the upturned edge of another disc, just above the centre of the fold (see fig. 65). These structures can be built up to any size and can be spherical, cylindrical or any shape you like. They can be used for lampshades or for decorative purposes.

The constructions in this photo are all white; they can of course be varied by using coloured paper of any kind or, for instance, oiled paper which would make them translucent. Alternatively, the basic unit need not be a circle — any polygon (squares, hexagons and so on) can be stapled together in a similar way (see fig. 67). The variations are enormous.

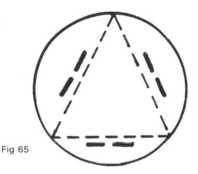

Fig 65

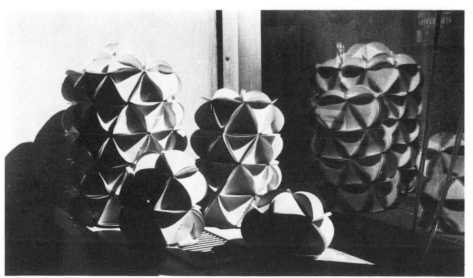

Fig. 66 Paper constructions (Courtesy New York School of Interior Design)

If you look at the diagrams you will see that the circular one, as used in the model, is by far the simplest. You will also realize that the diagrams for this construction are very similar to those making pyramids, cubes, etc, but the shapes are used inside-out, and are stapled instead of pasted. Any geometrical form can be made this way and all sorts of crystalline forms or molecular chains can be built up by varying both the basic unit and the manner of connecting it. Just think of the endless possibilities!

The construction in fig. 68 (photographed from two sides) could equally be called a sculpture — paper sculpture. It is made from two-sided cardboard — one side white, the other black. The shapes have been cut with a very sharp blade after marking the outlines; where one part is apparently joined to another, as where the foot comes out of the body at a right angle, the board has been

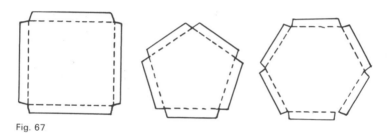

Fig. 67

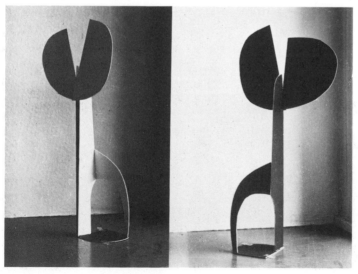

Fig. 68 Paper sculpture by Mary Joan Gelin

lightly scored on the inner side and cut more deeply on the outer side without, however, cutting right through, and has then been bent. You can see a vertical narrow strip running all the way up on the left-hand photo — this has been cut and bent in the same way. The 'head' is made from two near-semicircles, each cut separately and then glued on; note the very subtle tilt and overlap.

In spite of its technical simplicity, this is a work of very professional craftsmanship and great precision — a classical and static piece with only a hint of movement; carefully controlled and logically persuasive, it is a rich and complex statement. Although only about 1 ft. 6 ins high, it has scale, and could well be blown up to a large size and executed in wood or metal.

In fig. 69 (the same piece seen from two different angles), a corrugated cardboard column has piled around it a variety of forms which are not usually found together: cylinders, flat discs, a wedge-shaped folded-over form, a disc with a zig-zag rim, an oblong window, etc. The white corrugated board contrasts with the smooth blue surfaces of all the flat shapes. It is so full of ideas which could be explored further that it should really be developed into several pieces. Yet, as it stands, it is quite bold and gay and venturesome — and certainly easy to make.

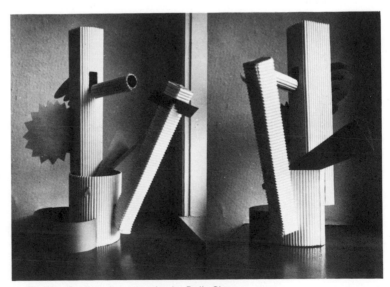

Fig. 69 *Cardboard construction* by Emily Shaw

Before cutting the corrugated cardboard for the smaller column, where the direction is against the corrugation, it had to be scored both inside and outside, then bent. The parts are put together by slotting and gluing, with the exception of the small cylinder coming out of the oblong window, which is resting on a knitting needle going through the large pillar. This pillar needs a square block inside in order to keep its shape.

This piece has no base. The question of how to mount, or display, a construction is interesting: traditional sculpture was always put on a pedestal (in both the literal and figurative sense of the word) or, if small, on a block. In this book you will see many pieces without a base. You may have asked yourself why some have a base and others do not; or you may have accepted it as the right and natural thing in any one case, without much questioning. Such acceptance probably proves that the problem has been solved – only a jarring note would have made you aware of there having been a problem at all.

As a general principle, any kind of base should be part of the construction, or sculpture, not something extraneous used for the piece to stand on. In fig. 68 for instance, the base is part of the piece, whereas the construction discussed above has none and does not need it; the same is obvious for the piece on the cover, especially when it is hung, as also for fig. 16 where a base would inhibit the quality of movement. The construction of tobacco tins (fig. 15) would be ruined by the introduction of another element underneath it; and the surrealist piece on page 90 (fig. 81) surely stands very much on its own feet (foot). The two figures on page 83 again just have to be allowed to walk about freely – and so on, for all freestanding work. There is a parallel to this in the modern way of framing, or not framing, paintings: if the subject is not just a composition within the space of the canvas but could go on in one or more directions, or if the background alone is enough, it is better to leave off the frame. Much the same goes for three dimensional work. It is more intimately part of our environmental space without any base or pedestal.

Paper can also be used for making reliefs by cutting it in different ways. The next illustration shows, on the right, a very effective textured low-relief done in the simplest possible manner. Into a sheet of cartridge (drawing) paper were cut regular semicircles,

which were then raised a little to stand away and catch the light, or throw a shadow. The paper has of course to be marked out in fine pencil with set square (triangle) and ruler, first into the four large areas and then into parallel stripes so that the repetition of the pattern is absolutely accurate. Notice how the halfmoons go in four different directions in the four different fields and how this determines the pattern.

The left-hand panel is a gay affair in white, orange and pink. The paper squares used were 2 ins × 2 ins and 4 ins × 4 ins. They were all folded over twice from corner to corner and cut very simply, this way and that, but some finely and some in wider strips, some more irregularly than others. Some are pulled out in the centre, some superimposed on others, or pushed inside and underneath, and a three-dimensional effect has been achieved by the subsequent manipulation of a simple basic design.

The half-moon relief was cut with a sharp blade, the squares with a pair of scissors.

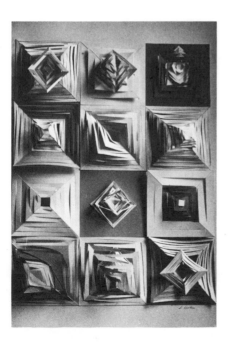

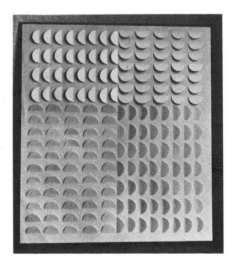

Fig. 70 Two paper reliefs by Louise Weber

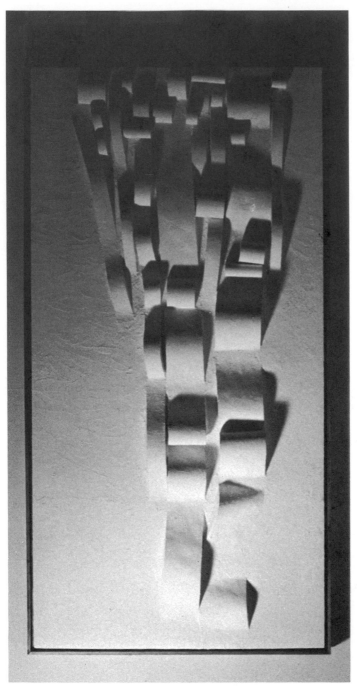

Fig. 71 Paper relief by Håkan Carheden, 3ft × 6ft

The paper relief shown in fig. 71 is made from adding-machine tape (like ticker tape). A piece of softboard 3ft × 6ft (see page 18) has been prepared with modelling paste (acrylic putty) as in fig. 10; the strips of paper have then been cut into different widths and arranged on the board to form a variety of loops — long and shallow, shorter and higher, and, at the top, loose and close together. The strips are not all vertical, there is some play with slanting and irregular arrangement. The ends of the strips are embedded in the modelling paste and the loops are also held down by the paste to varying degrees of depth and length. This variation of a uniform material creates an interesting rhythm reminiscent of a waterfall, or of the coil and recoil of a wave. The whole panel is white.

Another relief, by the same artist, is more complex (fig. 72); it is made from different elements including paper: there are round and oblong units, flat bands and hollow spheres. The panel is again softboard with modelling paste; the circular shape is composed of Styrofoam balls (expanded polystyrene) of different sizes and plaster moulds made from them for the hollow spheres, and of rectangular pieces of wood and irregular strips of cardboard. Note the way in which the full spheres are grouped together, the biggest ones in the centre, then the half-spheres and the hollow spheres,

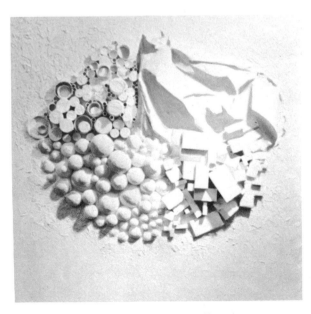

Fig. 72 Relief by Hakan Carheden, 4ft × 4ft

etc. in a carefully organized order.

The relief is sprayed all over with white paint; it is unframed and mounted to stand well away from the wall.

For information on the handling of plaster of Paris, I suggest you refer to the reading list at the end of this book. The hollow spheres in the relief shown here could be made from halved ping-pong balls instead of plaster-moulds, or from inverted screwcaps; mothballs and marbles would provide other small round balls.

The relief panel shown in fig. 73 is made from softboard on a softboard base. It is built up from several layers of strictly vertical and horizontal, i.e. rectangular, shapes, on the principle of a relief map but, of course, in a purely decorative way. The shapes are cut out and glued onto the base layer by layer, allowing the baseboard to show in certain areas as part of the design. On looking closely you will see several pieces of fine square molding with little nails sticking out — an almost graphic elaboration of the right-angle design. White spray paint, and a batten of wood nailed round the edge, complete the panel. The shadows indicate the thickness of the various layers of board making up the relief. It measures 2ft × 4ft.

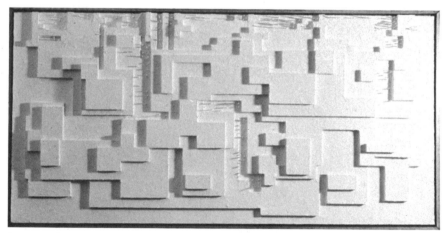

Fig. 73 Relief by Håkan Carheden

More found objects, combined with new materials

These two figures are really a three-dimensional cartoon on the Woman's Lib movement. They are made from papier maché: scraps of newspaper soaked in water and pasted on, layer upon layer, with cold water (white or flour) paste, over old bottles or jars. Their mops are on bits of cane stuck into their hands. When dry, the papier maché was painted over in bright primary colours and varnished with shellac.

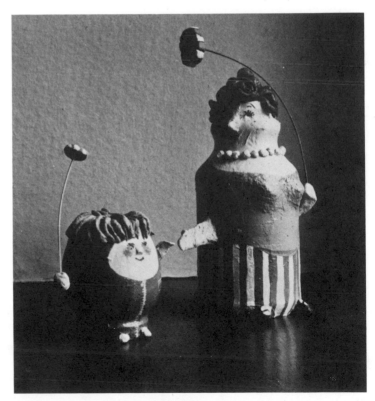

Fig. 74 *Woman's Lib* by Mary Joan Gelin

The wooden mask (fig. 75) is from East Africa; it is used in ritual dances, held before the face, much as masks were used in Elizabethan England in plays and 'Masques'.

Fig. 76 shows a modern adaptation of the old idea. Here, however, the masks cover not only the faces but everything down to the legs, and they are given an ambiguous twist by allowing the body to show through in places; also, by mounting the face-masks on those box-like frames, the people behind them are made to appear more mechanical — an allusion to our mechanized society. The garish colours and simplicity of the design allude to the circus and funfair, or to popular parades. They can serve as ideas for use in fancy dress balls and on the stage. (What a gay idea for a ballet!)

The frames are knocked together from plywood, then painted and laced across with string and decorated with coloured paper cutouts. Both these masked girls are wearing ordinary Guy Fawkes (or Halloween) masks which have been overpainted; the right-hand one also has a cat mask on top of it. The hair of the left-hand figure is made from curled-up tissue paper, and she is wearing a dress made from reflecting silver plastic behind her frame; the beads are fixed to the frame and not to the girl's neck, an idea which accentuates the symbolic character of the mask. The right hand figure has hair of fine transparent plastic and her box-mask is made from a wooden tray with an inset of wire mesh behind which there are two clock faces in the place of the breasts; the lower half is a wooden box with paper-collage.

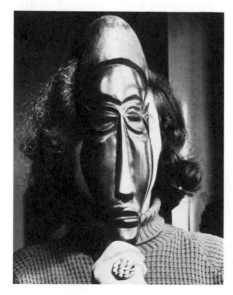

Fig. 75 African mask

Fig. 76 *Masked Figures* by Jack Yates

Little boxes filled with all sorts of things are another type of construction that is popular at the moment. The idea is a take-off of the old peep-show and also of the showcases of nineteenth-century shops such as pharmacies, in which all sorts of mysterious 'remedies' were put. Some of these new boxes are divided up into little compartments holding a rich variety of whimsical oddities, a reference to the hoarding and collecting instincts many people have; others show an aspect of some of the absurdities of contemporary life. Most of these little peep-shows have some reference to present-day life or make outright comments on it, often of a satrical nature. They can be pure fantasy and carry nothing but personal symbolism, or they can convey a more general meaning.

The box shown here (fig. 77) is a combination of several components: it refers to the past by the use of Victorian wood-carvings and the little statue on the top; it refers to the strip-tease peep-show of the modern amusement arcade; and the idea of the 'bottled' woman may be just personal fantasy. The use of photographs is a direct reference to film and advertising and also accentuates the contrast between the three-dimensional 'dead' objects (box and bottles) and the flat 'live' figures. The piece is rich in allusions.

The whole construction, including the little porcelain figure on top, is painted blue. The bottles are filled with water, and the photographs are placed behind them; those at the sides are of the

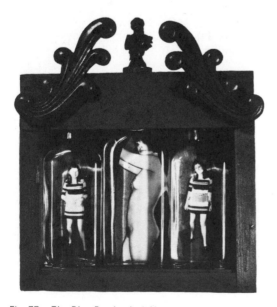

Fig. 77 *The Blue Box* by Jack Yates

same girl in different poses. The centre photo of the nude is placed so as to get the utmost clarity but the distortion near the edges, caused by the water in the bottle, is intentional. The fascination of seeing things through water is the key to this construction.

Jack Yates' fascinating work with boxes has an affinity with the work of other artists in this field — the best known is Joseph Cornell, who specializes in them. Cornell's boxes are poetic and surrealist and full of allusions. He is referred to in the reading list at the end of the book.

There are other kinds of boxes made by a number of artists which are sometimes seen in exhibitions, such as the lidded one shown in fig. 78. They are pure fantasy, and rely for effect on the absurd contrast of objects used and of textures expressing different feelings. The one shown here combines a stuffed bird with pins and a handful of string: a dead creature, soft feathers, imprisoned in a box covered with the most agressive, spiky material forming a sort of palisade along the rim, with the beard-like bunch of string adding a feeling of disorder and dereliction. The piece is mounted on a dark, almost invisible block of wood, so that it looks like a head in mid-air.

The idea is weird and whimsical and very personal; the technique is simple. The bottom was taken out of an old drawer and

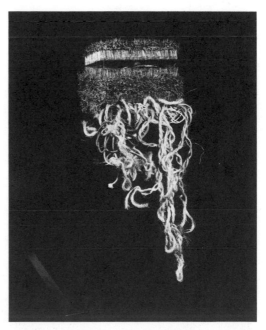

Fig. 78 *Untitled Box Number 3* (1963) by Lucas Samaras, 24 1/2 ins high. Whitney Museum of American Art, New York (Gift of the Howard and Jean Lipman Foundation, Inc.)

a wooden lid hinged on top; the rows of dressmakers pins were fixed to the rims in rows with a clear flexible cement; bunches of pins were put on top and on the sides and the cement was poured over them out of the tube, bunch by bunch; the string was stuffed in underneath.

An object of daunting size, but one which may well be found in any old house, is the wardrobe, here transformed into a field for military operations (fig. 79). Hundreds of toy soldiers are stuck on — in patterns of drill and parade-ground inside, swarming into attack towards an objective at the top of the door on the right, scurrying over the rooftops, and forming different patterns of military action on the outside of the doors. The whole thing is sprayed white.

The bizarre effect is achieved by an original juxtaposition of unrelated and incongrous materials — materials taken out of their everyday context and deployed here as something other than what they usually mean. Yet the fact that we cannot forget that the wardrobe is also a wardrobe makes it weird and funny.

The construction shown opposite would be almost a grand

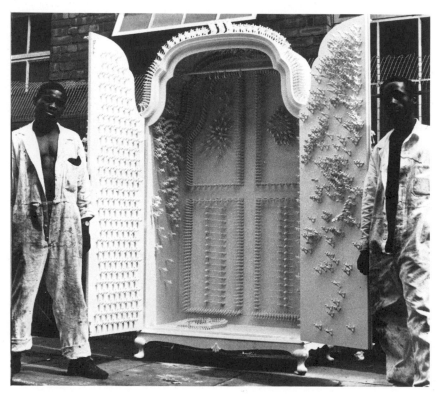

Fig. 79 *Soldiers* by Antoni Miralda

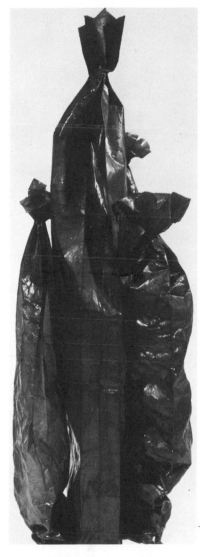

piece of sculpture (it is over 5ft high) were it not for the fact that it consists simply of four brown paperbags, quite unconcealed and bare, not even coloured. To me it suggests a family group — so vividly that I cannot see anything else. The bags are of slightly varying colour, tied at the top. The centre one is used smooth, the others are crumpled. Accident has been allowed to play a considerable part in their making. In order to fix their shape and to preserve them they have been varnished with polyester resin, one of the modern media much used today. The procedure is simple enough, but needs some experience and skill. It is best to learn it from someone familiar with it or from any of the booklets given out by suppliers available from sculpture supply shops) — it cannot be satisfactorily described here. In principle, the resin forms a resistant skin on whatever it is applied to, keeping out the weather and any chemical corrosives. If applied thickly it will resist pressure, especially when used in several layers. It can be left clear or painted over or sprayed with paint. This resin, in conjunction with glass fibre (Fibreglas), is used industrially for boats

Fig. 80 *The Orriginal Bags* (1969) by The Orr, 62 ½ ins high. Whitney Museum of American Art, New York (Gift of the Howard and Jean Lipman Foundation, Inc.)

and cars. It can be bought in small quantities for home use, together with a catalyst which will make the viscous resin harden. In the case of these bags only a little catalyst has been used, to ensure slow drying and easier manipulation. Some of the bags were weighted down with stones and suspended from the ceiling while drying.

The next two constructions belong to the world of dreams although they have here become physical manifestations, made of real found objects. They represent the realism of the unreal, generally described as surrealistic — a metaphor of the real world in its own irrational, illogical way. They are visual condensations of meaning which can otherwise only be expressed in poetry. This sometimes humorous, sometimes bizarre effect is achieved by unexpected combinations of materials, and by the juxtaposition of incongruous objects.

Fig. 81 is a good example of this: the foot is a polyester resin cast of the artist's own foot, connected by two dowel rods to a rubber ball and then to a head which is in fact a wigstand from Woolworths, all sprayed with black paint. Watch parts are stuck on to the

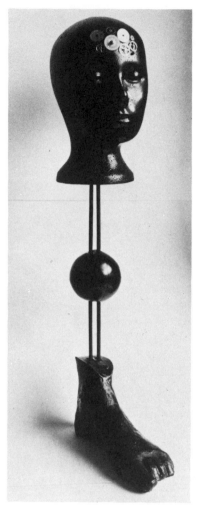

Fig. 81 *Fantastic construction* by Emily Shaw

forehead – as if to show what makes the lady tick.

In the next construction, called 'Poetic Object' (fig. 82) the symbolism is far less clear. There is a toy fish on the brim of a man's black hat (respectability), an old map of the world (perhaps indicating the business of the hat's owner, or showing that the piece has a universal meaning?), a hollowed out wooden post inside which is suspended a woman's leg in an evening shoe; the leg is a stocking stuffed with cotton-wool (absorbent cotton) – in relation to the man this may well be of fetishist significance. Beside the leg dangles a ball, repeating the form (and perhaps meaning) of the world on the map, but now shrunk beneath the ridicule of the foolish stuffed parrot. Perhaps the message is also that everything is just a game; the parrot again has associations with a lady's boudoir, or simply connotes an aping fool, mouthing empty words. Reading such a piece is a personal matter and allows for

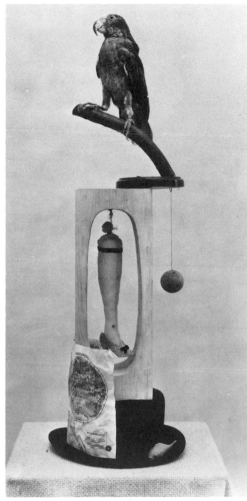

Fig. 82 *Poetic Object* (1936) by Joan Miró. Construction of hollowed wooden post, stuffed parrot on wooden stand, hat, and map, 31 7/8 ins × 11 7/8 ins × 100 1/4 ins. Museum of Modern Art, New York (Gift of Mr and Mrs Pierre Matisse)

a wide range of interpretations. This is intentional, for the artist may not be aware of the symbolism any more than in a dream, or he may wish the spectator to project his own meaning into the framework of the piece.

Technically the work is simple: it only needs a block of wood under the hat to support the weight of the objects on top of it and a few screws to hold it together.

Making constructions with children

The advantage of using materials of the kind described in this book are even greater when working with children. Their abundance and cheapness make for a very relaxed atmosphere — there is never any anxiety about ruining something precious, an anxiety which can be extemely inhibiting; on the other hand, the many associations attached to found or discarded objects which are familiar to children will be very stimulating to their imagination. The transformation of everyday objects into something imaginary is, after all, an essential part of children's play; transformation and magic lie close together, and creating monsters, for example, from domestic rubbish will be enormously gratifying to fantasies of omnipotence or ritual magic. Acting out or projecting wishes and fantasies in this way can be fruitfully exploited for educational and therapeutic ends. But even if such work serves no other purpose than to keep children happily occupied, it will be found rewarding.

One material which is, of course, equally useful for adults and for children but which has barely been mentioned before, is expanded polystyrene (Styrofoam). It is seldom necessary to buy it, as it is widely used nowadays as packaging for many household, office and workshop goods.

The relief shown in fig. 83 was done by a schoolchild aged about seven; most of the cutting is done with a wire loop heated over the flame of a candle; it is used like a cheese-cutter but works rather more easily. A sharp knife can be used for cutting right through, and large pieces can be cut with a saw. The oblong piece on the left has been glued on.

Before using an adhesive, be sure to try it out on a spare piece because some kinds dissolve the polystyrene. When experimenting with this material, pieces can be held together with pins until the idea has taken definite shape. A finished piece can be painted or sprayed to cover the not very attractive surface texture or it can be varnished, or covered with glued-on tissue paper and then painted. Again, it is advisable to experiment on a spare piece of material first.

'Tubes in space' (fig. 84) was made by seven-year-old schoolchildren, out of old glossy magazines. Colourful pages were used to make rolls of varying thickness and length, straight or tapering. Many pairs of hands were needed to hold the tubes in place while experimenting with the design. The construction is held together

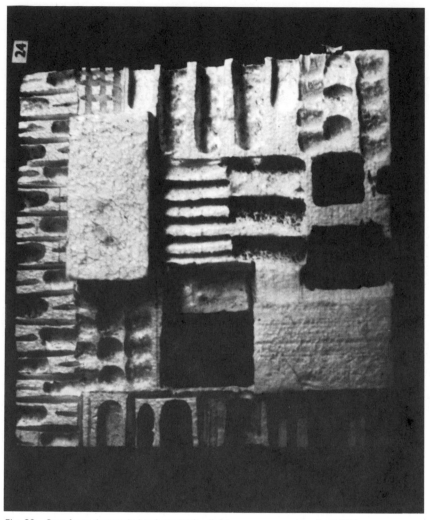

Fig. 83 Styrofoam (expanded polystyrene) relief by seven-year-old schoolchild

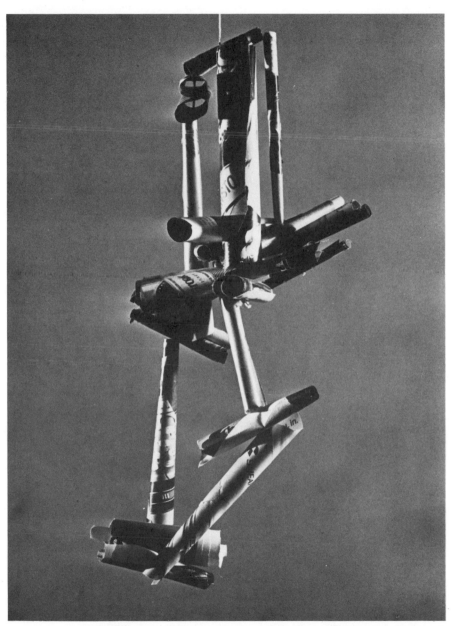

Fig. 84 *Tubes in Space* by pupils of Janet Carson photographed at Wisconsin University, Eau Claire by Jack Cristofferson

mainly with glue but also with pins and string. It is suspended from the ceiling.

Children always enjoy making masks. A primary school class set out to make 'a scary monster, a Cyberman', and fig. 85 shows one of the results, made by a nine-year-old girl. A cardboard box is covered with tinfoil, with light bulbs for eyes, wire for a moustache and bits of fur for hair; note the bird nesting in the hair and the rose and bow diminishing the monster's ferocity, and the hairstyle with a fringe coming right down to the eyes.

The next illustration (fig. 86) shows four more masks made by children. The one at the bottom, left, has plenty of hair too, made of lanky wool streaming down in a fringe and right to the shoulders, with moustache and beard to match; the long nose, sallow face, beads and dark glasses make this the perfect hippy type. How well this child has chosen his materials to convey character. The paper tube stuck in for an ear makes an amusing contrast.

Fig. 85 Mask (front and back) by a nine-year-old girl

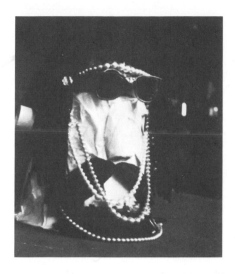

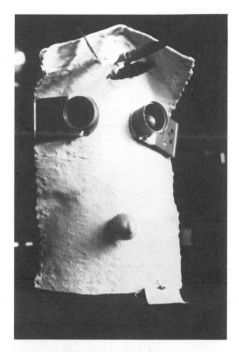

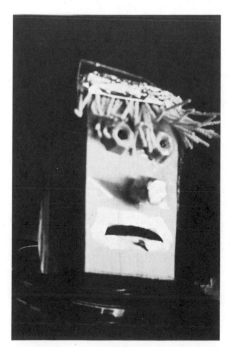

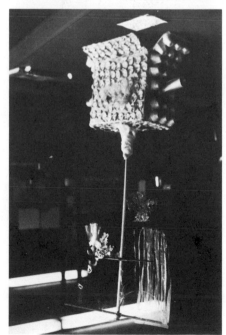

Fig. 86 Hallowe'en masks by pupils of Christopher Hatton School

The top right-hand one is very different: a splendid helmet, belonging more to the world of medieval chivalry than to the present day. Here are the egg cartons again, glued to the ends of a corrugated cardboard box, with bottle tops stuck to the sides and top. Masculine aggression is symbolized by the tubes sticking out from either end. The spike of the helmet is made from dowel rods, looking rather like a TV antenna and hung with glittering tinsel decorations probably saved from Christmas. What an elegant, haughty piece can be made from such rubbish!

The other two masks in fig. 86 show considerable similarity: the shape of the boxes, the staring eyes made from scrap metal in a white-painted face, the low foreheads, wool (yarn) for a fringe

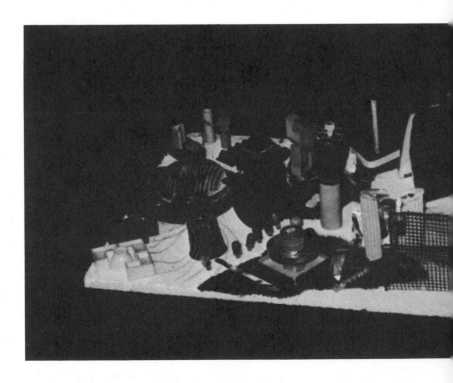

in one, funny feathers in the other. I like the seed pod stuck on for a mouth in a noseless face.

'City of the Future' was a project made by a nine-year-old boy, assisted by his eight-year-old brother. Work on it spanned two Sundays. The base is a 4ft × 8ft panel of expanded polystyrene and the materials used are domestic and electrical discards, some car components and bits of broken toys. The large blue painted areas on the board represent an expanse of water which is bridged at various points; the lake on the left also holds an enormous structure rising out of it, a number of piers and platforms and two highrise blocks with radar devices on top. The scale is such that people would be no more than pinpoints on

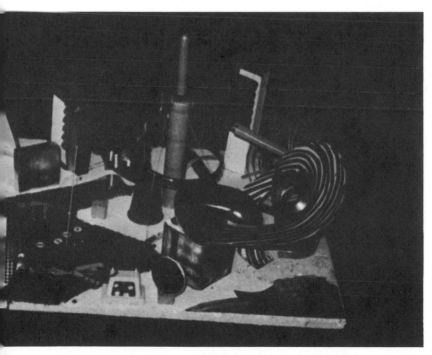

Fig. 87 *City of the Future* by Ian and Ralph Hunt

this board, so they are not shown. To the right is radio-city consisting of complex buildings serving advanced electrical and computerized industries. In the middle are two giant blocks of flats (apartment houses), green and red, each consisting of two slabs converging towards the top and representing many hundreds of units. The high buildings are left with ample space surrounding them for gardens and recreational facilities.

Wire and glue was used to fix the objects to the base. No artistic merit can be claimed for this work but I believe that it is educationally valuable in giving visual three-dimensional expression to thoughts about our environment; it sets children thinking about the planning of the future they themselves are going to build. And it is fun.

Fig. 88 Mini-construction by the author

Conclusion

I hope that in the course of this book I have succeeded in showing you what a lot of fun and excitement can be found in this kind of creative three-dimensional work, and that you will be inspired to find many other ways in which to put together your own constructions.

I would like to end my exhortations to creativity with an idea given me by that ingenious couple, Dr and Mrs Shaw, some of whose work has been discussed earlier in the book, for a miniature project for every household. Begin building a small, growing construction in a place where people will be constantly passing it — in the kitchen, or a passage, or the entrance hall — so that everyone can add another little piece to it as the spirit moves him. I have started mine on the kitchen door, with a seedpod, an empty cotton reel (thread spool), a couple of fishbones, a chicken bone, some spikey seeds, a tiny key on a chain, a screw, Styrofoam rings, beercan clips, acorns, paper clips, a piece of dry seaweed, and some aluminium shavings. It is only a week old, and who knows how big it will grow or with what additions we shall surprise each other. A small spool of fine wire and a pair of scissors are kept nearby, so that inspiration need never be thwarted. It is astonishing how beautiful all these tiny forms look together — as you will see when you start your own.

The approach to materials and techniques discussed in this book could well be applied to other fields; one is puppetry, a field particularly suitable for work with groups, either in the family, in class or in holiday camps. There are many books available on the subject, including the one mentioned overleaf.

For further reading

Technical information
New Materials in Sculpture by H. N. Percy; Tiranti, London and
Transatlantic, New York, 1966 (good information on modern
ways of casting and polyester resin processes)
Plastercasting for the Student Sculptor by V. H. Wager; Tiranti,
London
Introduction to Paper Sculpture by A. Sadler; Blandford, London
Paper Sculpture by Paul McPharlin; Marquart & Co., New York,
1944
Metalwork in Secondary Schools; H.M. Stationery Office, London
Simple Wire Sculpture by Elizabeth Gallop; Studio Vista, London
and Watson-Guptill, New York, 1970
Simple Puppetry by Sheila Jackson; Studio Vista, London and
Watson-Guptill, New York, 1969
Creative Papier Maché by Betty Lorrimar; Studio Vista, London
and Watson-Guptill, New York, 1971
Creative Crafts for Today by John Portchmouth; Studio Vista,
London and Viking, New York, 1969 (good information on
adhesives and on using plaster of Paris)
Any books on Origami (paper folding)
Most handbooks on metalwork include sections on brazing and
soldering,

Historical and aesthetic
The Sculpture of Picasso by Sir Roland Penrose; W. H. Allen,
London
Picasso Sculpture — Arts Council, London, 1967
Dada: Art and Anti Art by Hans Richter; Thames and Hudson,
London and Harry N. Abrams Inc., New York
Dada by Kenneth Coutts Smith; Studio Vista, London and Dutton,
New York, 1970
Constructivism by George Rickey; Studio Vista, London, 1970
and George Braziller, New York, 1967
Marcel Duchamps by Arturo Schwarz; Harry N. Abrams Inc.,
New York, 1970
Masks by Joseph Gregor; Piper, Munich, 1936 and Benjamin
Blom Inc., 1968
Masks and Mask Makers by Kari Hunt and Bernice Carlson;
Abingdon Press, Nashville, Tenn., 1967
Joseph Cornell — catalogue of his exhibition at the Guggenheim
Museum 1967, published by the Solomon Guggenheim
Foundation, New York

Suppliers

The materials mentioned in this book can usually be bought from artist's suppliers or hardware and do-it-yourself stores.

Acknowledgements

The author and publishers would like to make the following acknowledgements for illustrations in this book:

Charles Hill: frontispiece
New York School of Interior Design: figs 2, 25, 39, 66
Ann Casimir: figs 3, 4, 46
Gimpel Weitzenhoffer Ltd: figs 7, 8
Robert Adams: fig. 9
Hakan Carheden: figs 10, 23, 71, 72, 73
Dr Ernest Shaw: 14, 29, 37, 52
Emily Shaw: figs 15, 38, 69, 81
Bill Amidon: fig. 12, 26
Guiseppe Sciola: figs 30, 32
Museum of Modern Art, New York: figs 33, 82
Bonnie Thomas: fig. 40
Morris J. Pinto and Cordier and Ekstrom, Inc: fig. 44
Marlborough Fine Art Ltd: fig. 50
Ken Partridge: figs 51, 53
Jupp Dernbach: fig. 54
Jack Yates: figs 76, 77
The Whitney Museum of American Art: figs 78, 80
Antoni Miralda: fig. 79
Janet Carson: fig. 84
D. McCarthy, Christopher Hatton School: figs 85, 86
Studio Moderne: fig. 9 (photo)
Louis Siltzbach: figs 30, 32, 41 (photos)
Geoffrey Clements: fig. 44 (photo)

Figs 12, 13, 15, 16, 17, 18, 21, 22, 26, 30, 38, 42, 58, 59, 60, 62, 68, 69, 70, 74 and 81 are the work of students of Professor Joseph Shannon, Teacher's College, Columbia University, USA.

Index

Set in 9 point Univers
Printed and bound by Parish Press, Inc.